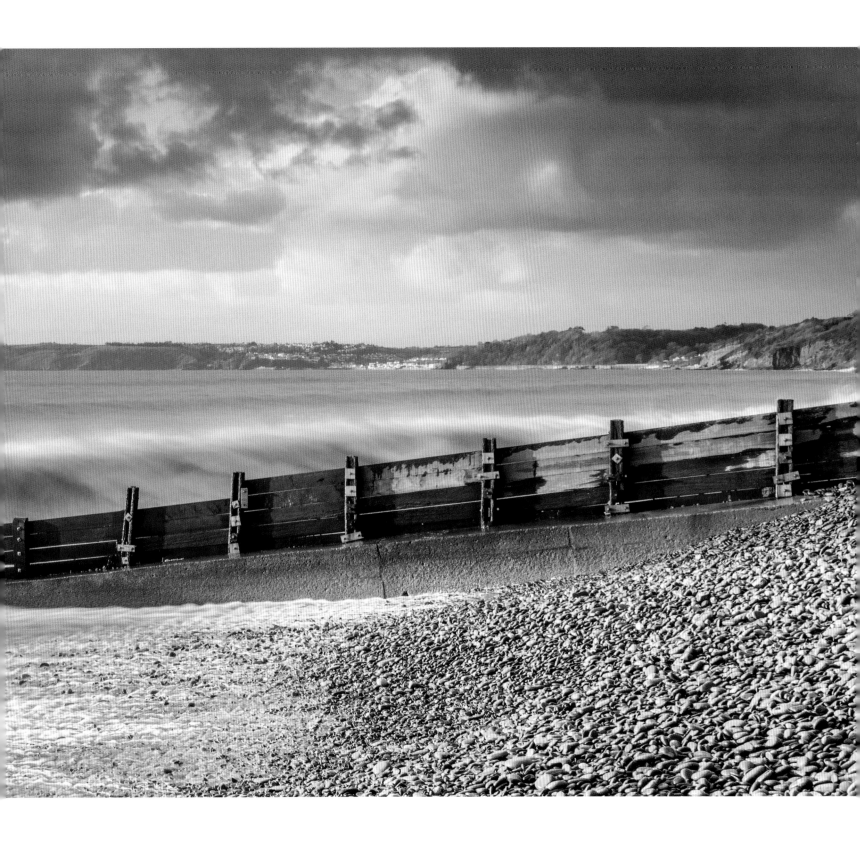

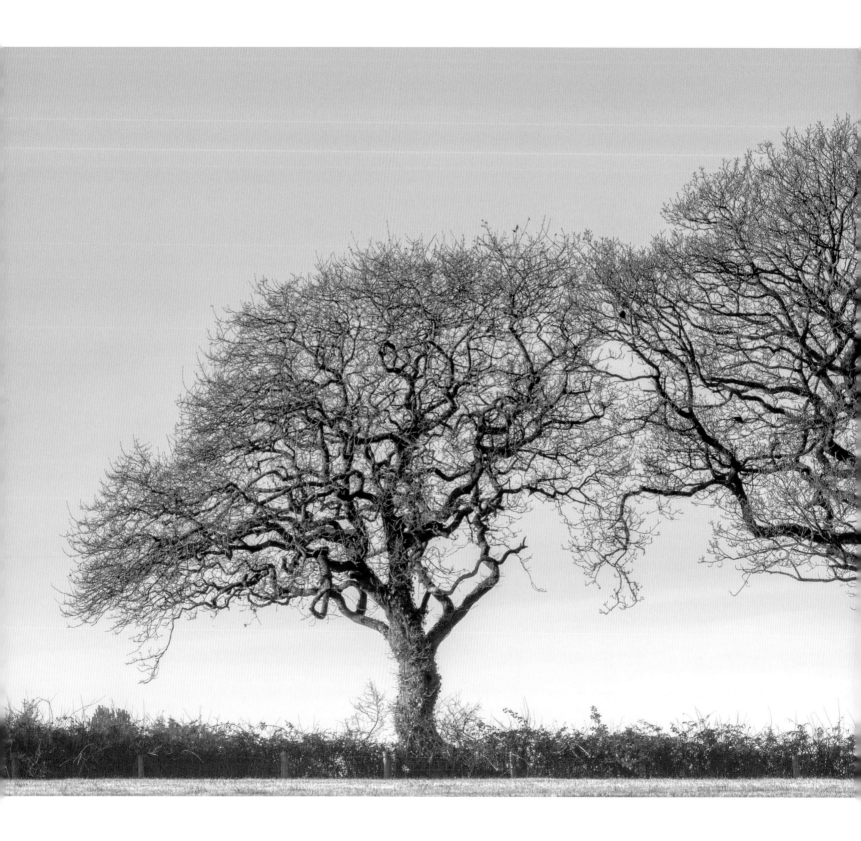

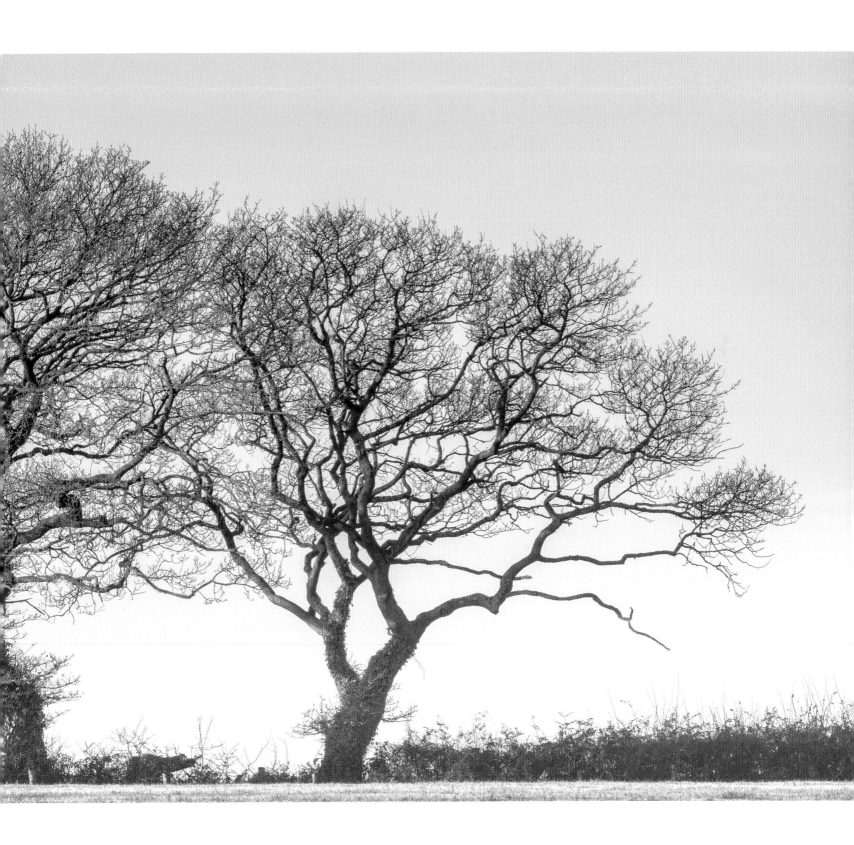

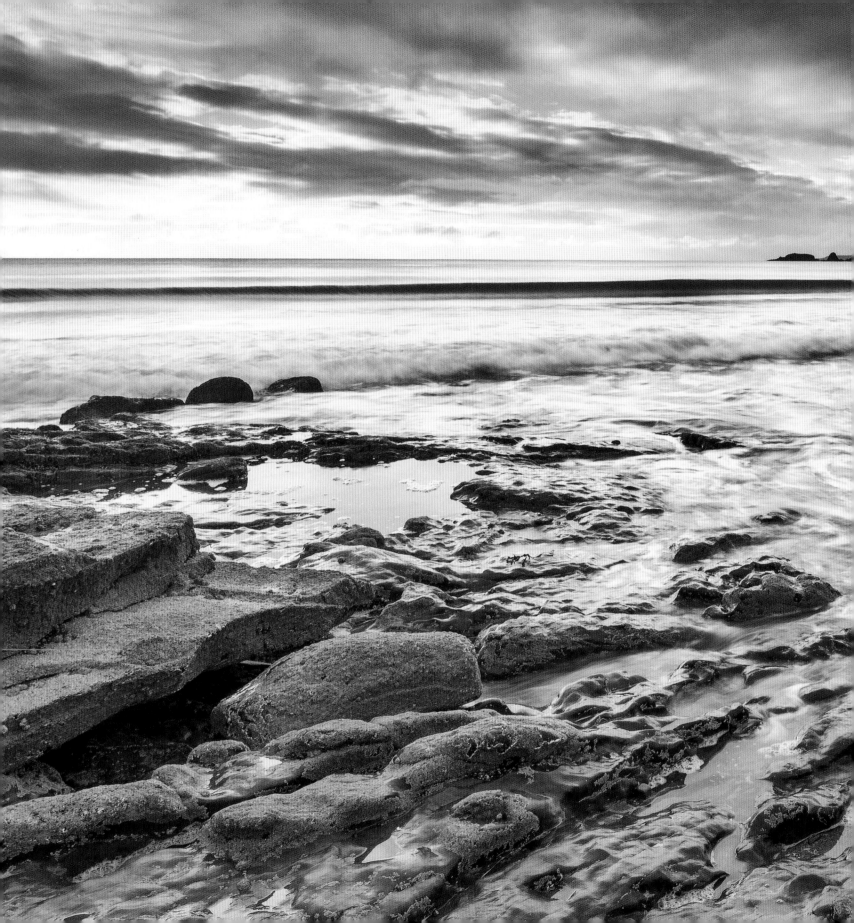

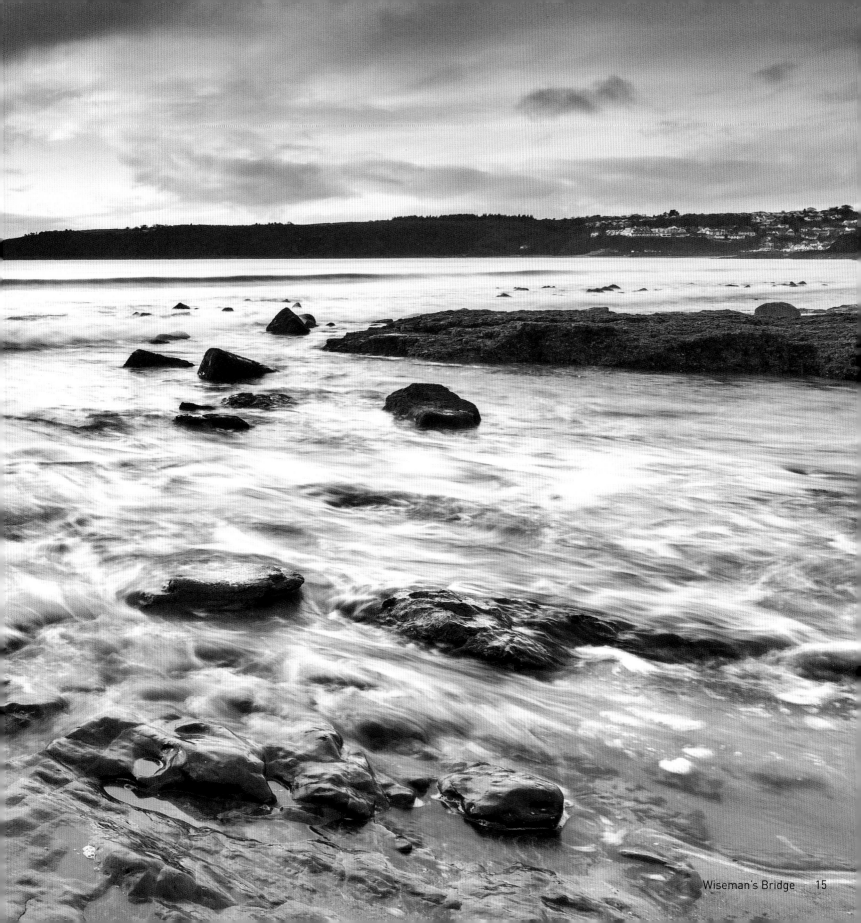

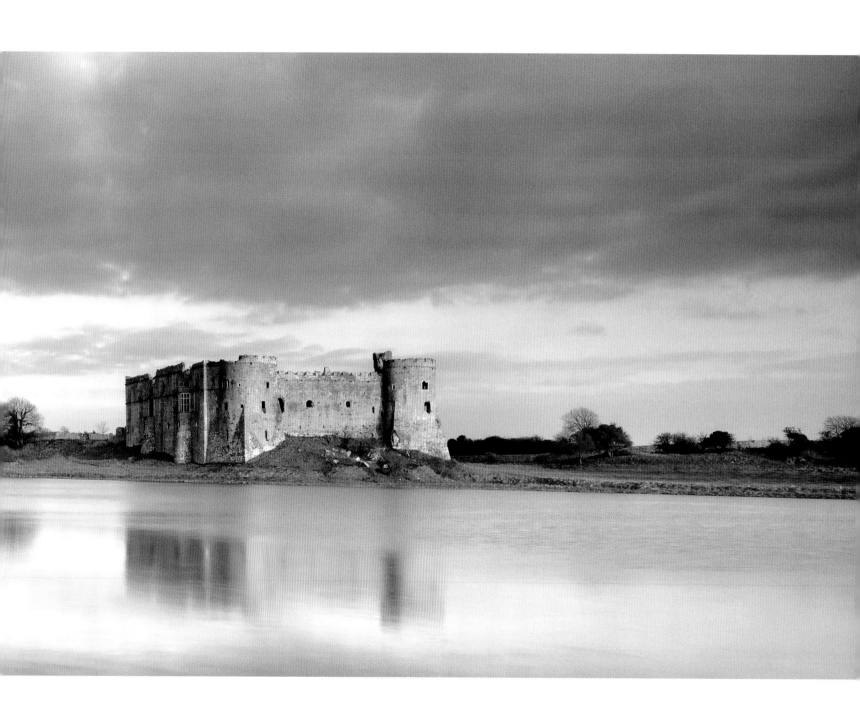

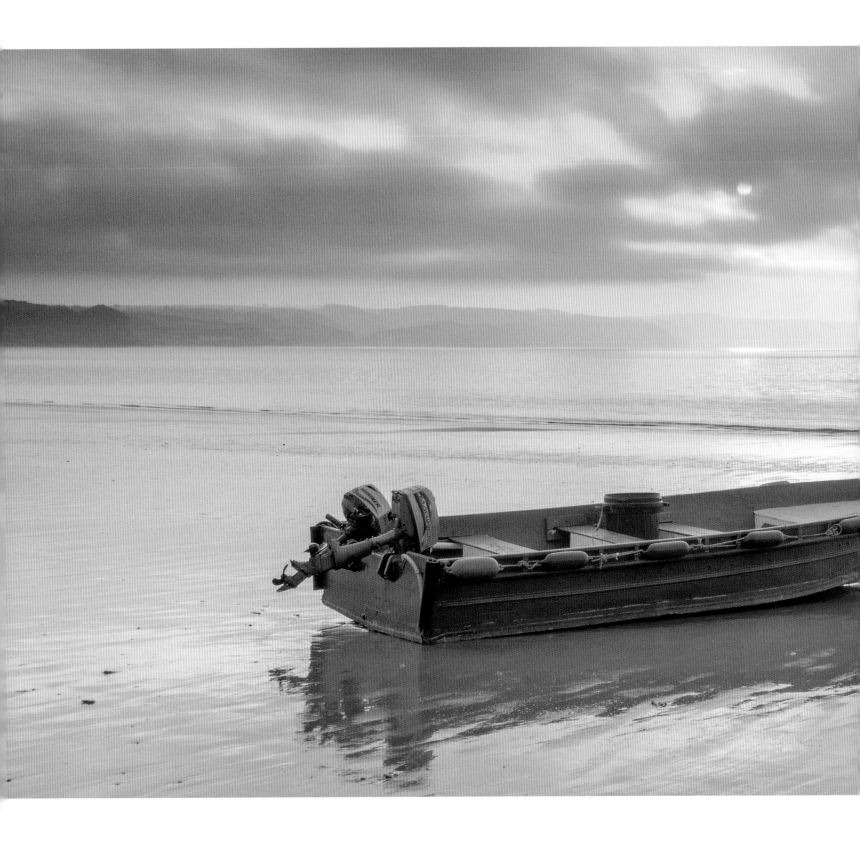

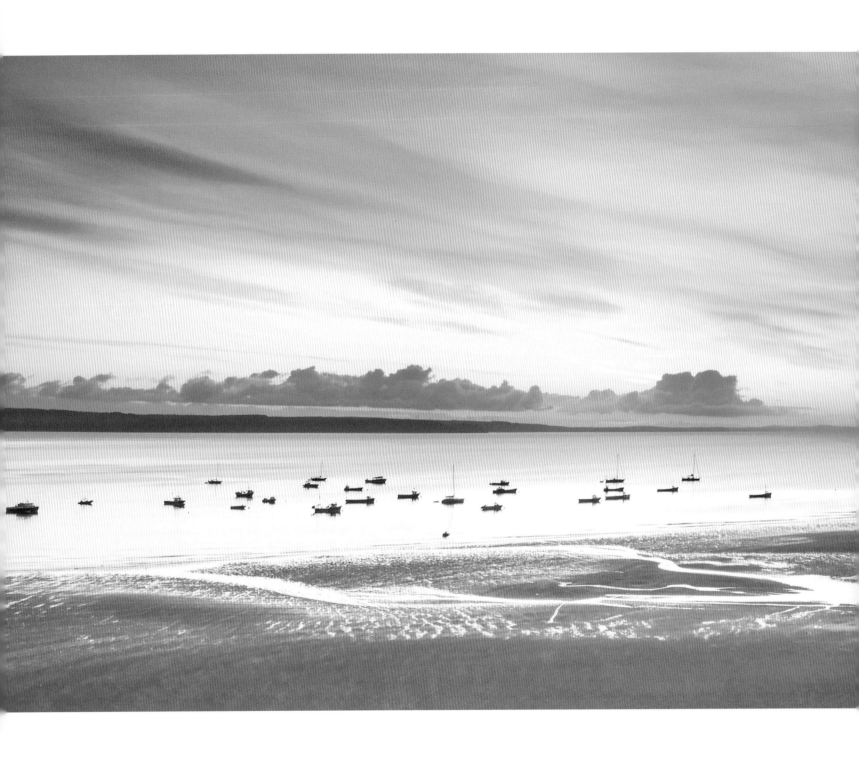

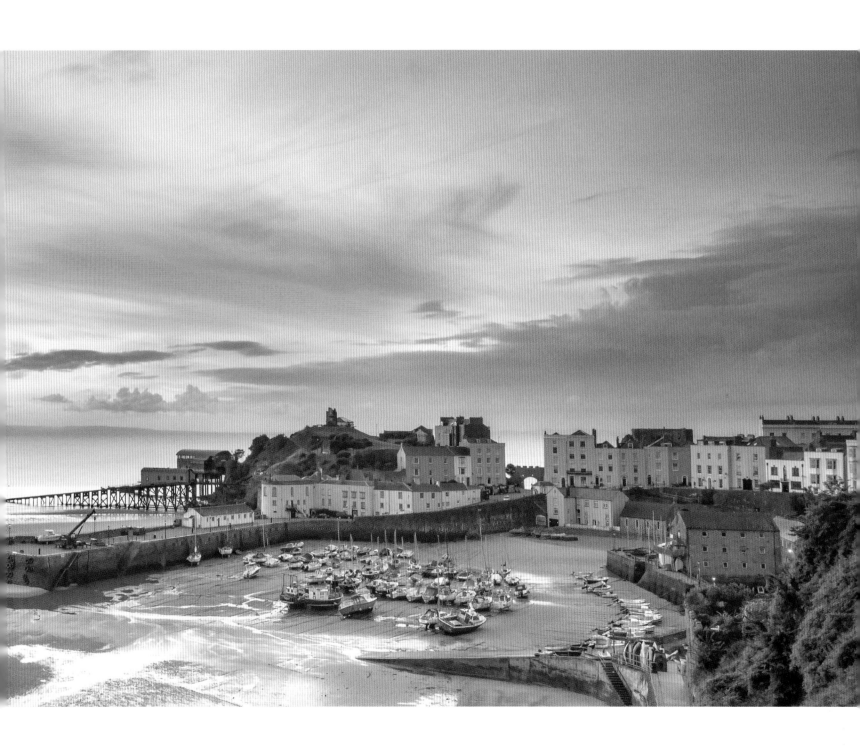

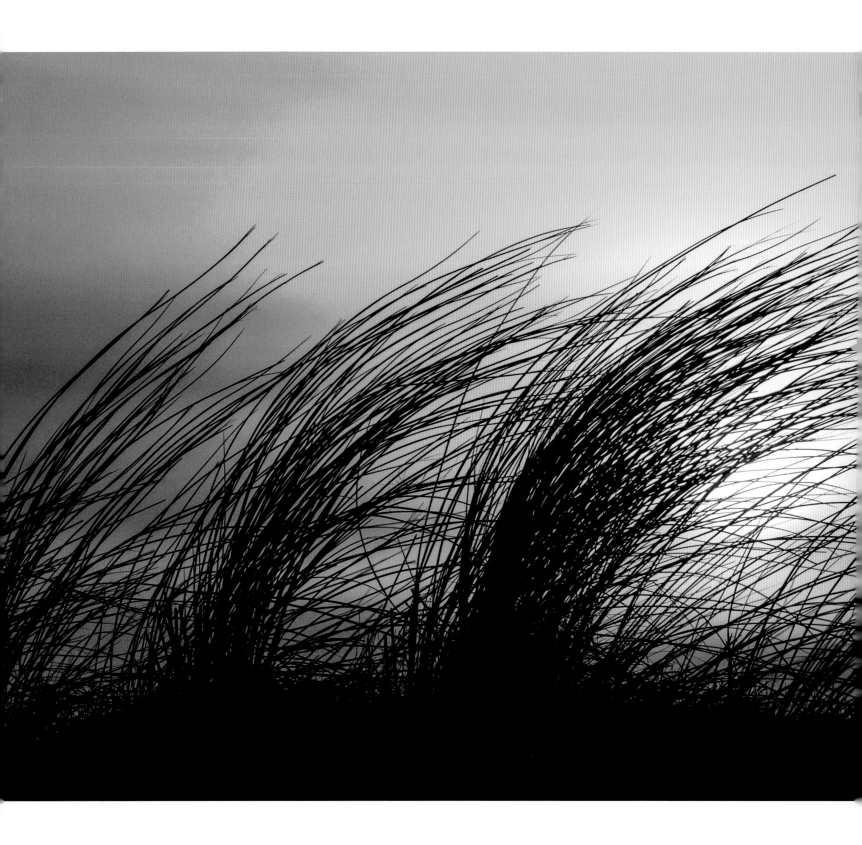

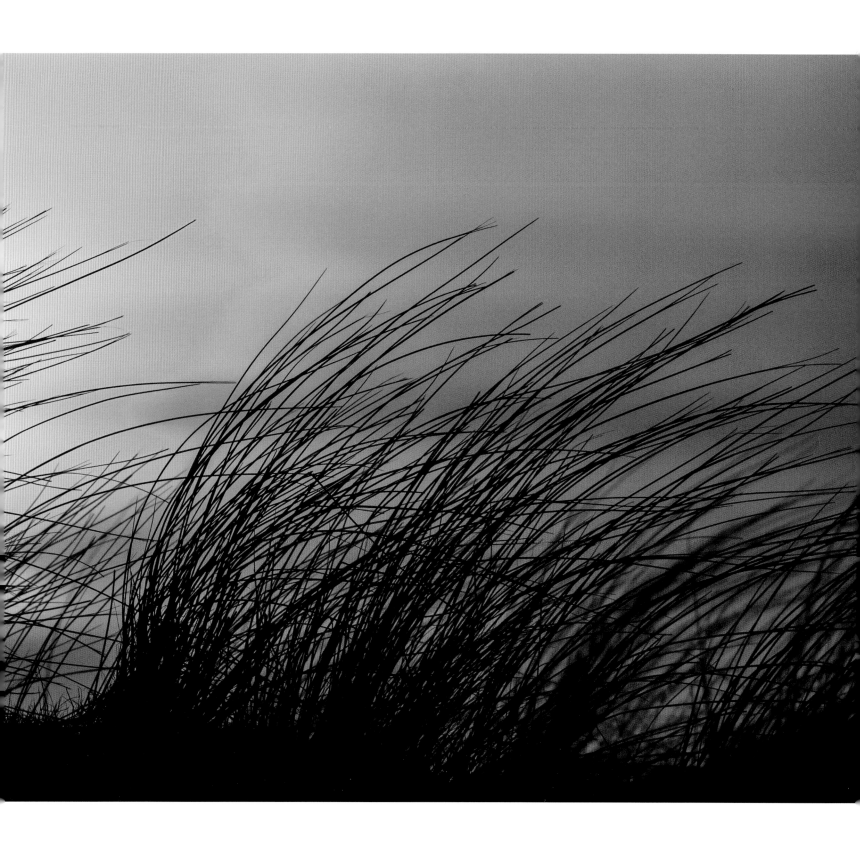

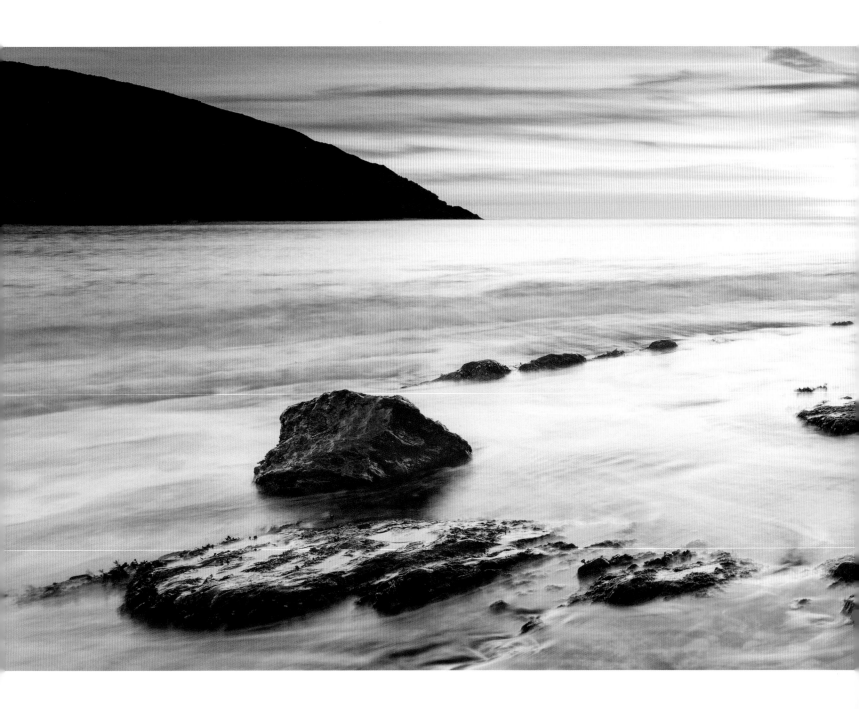

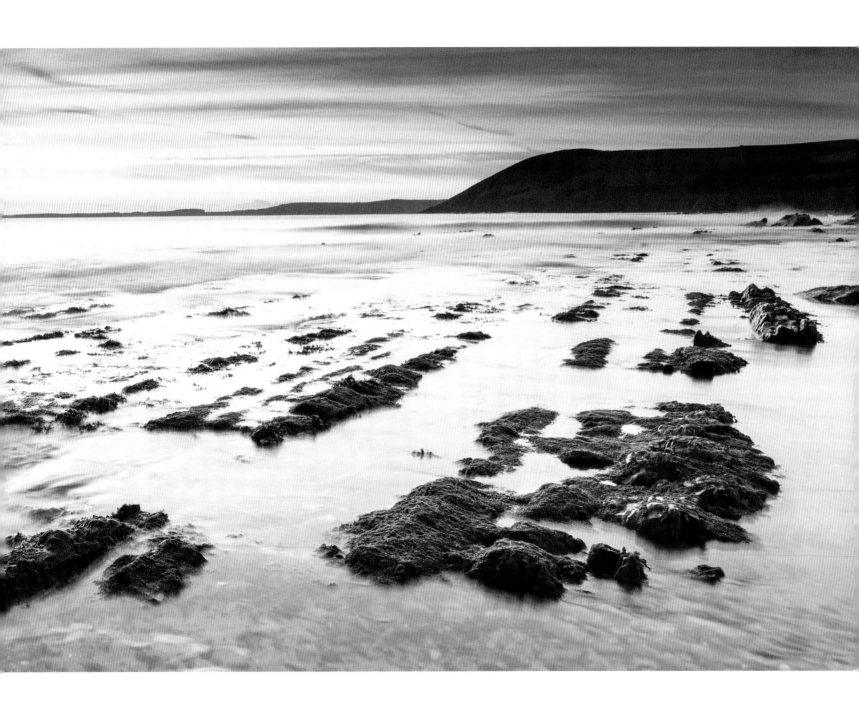

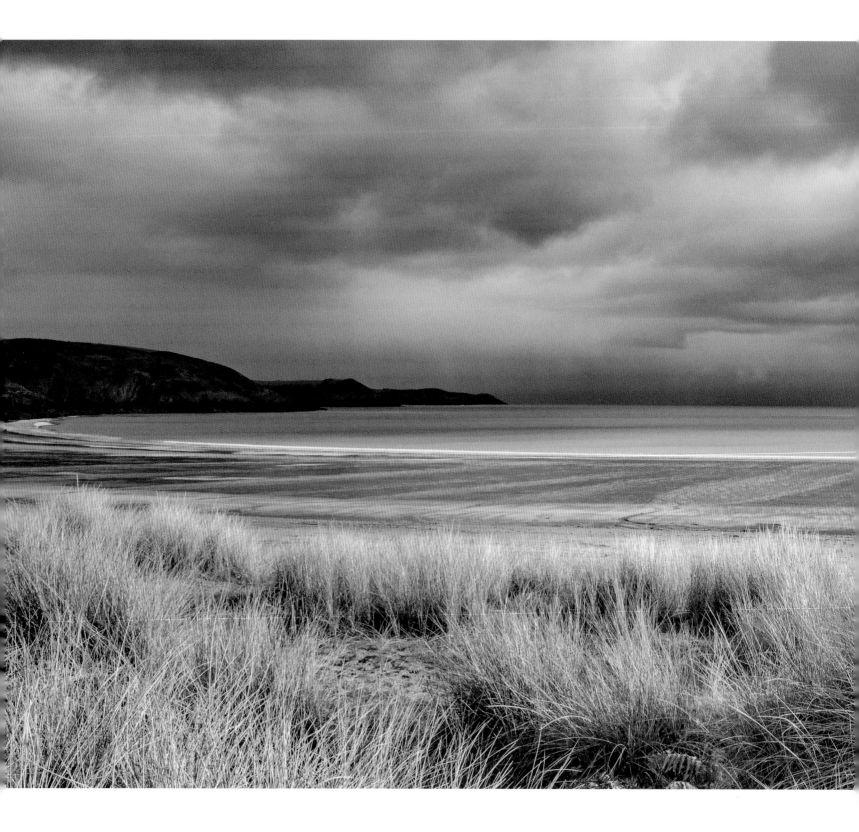

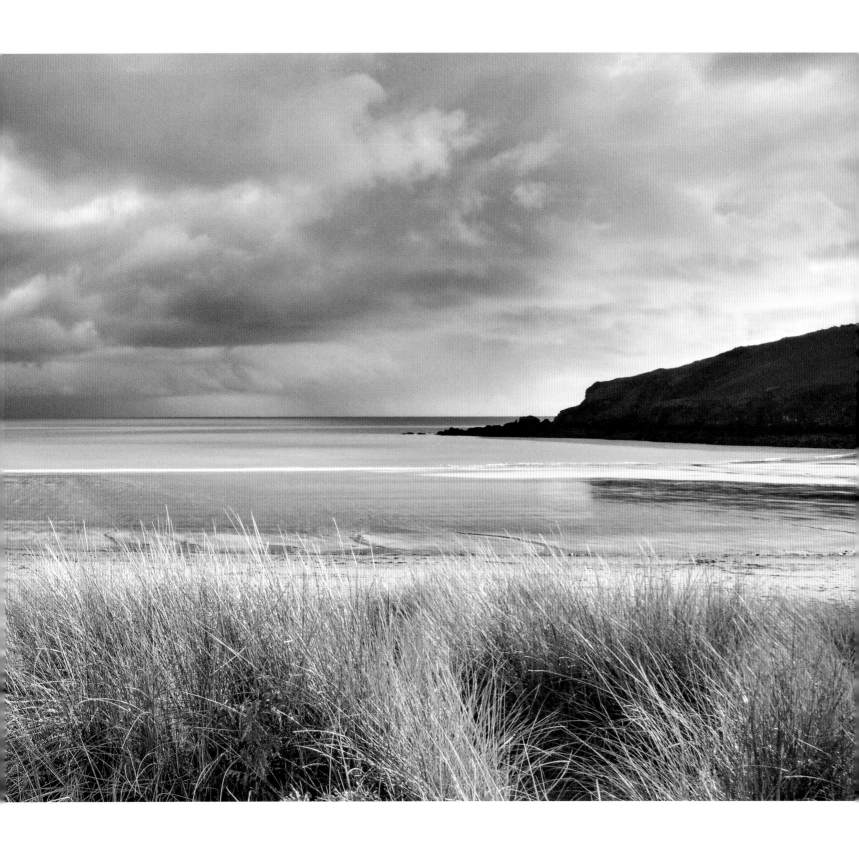

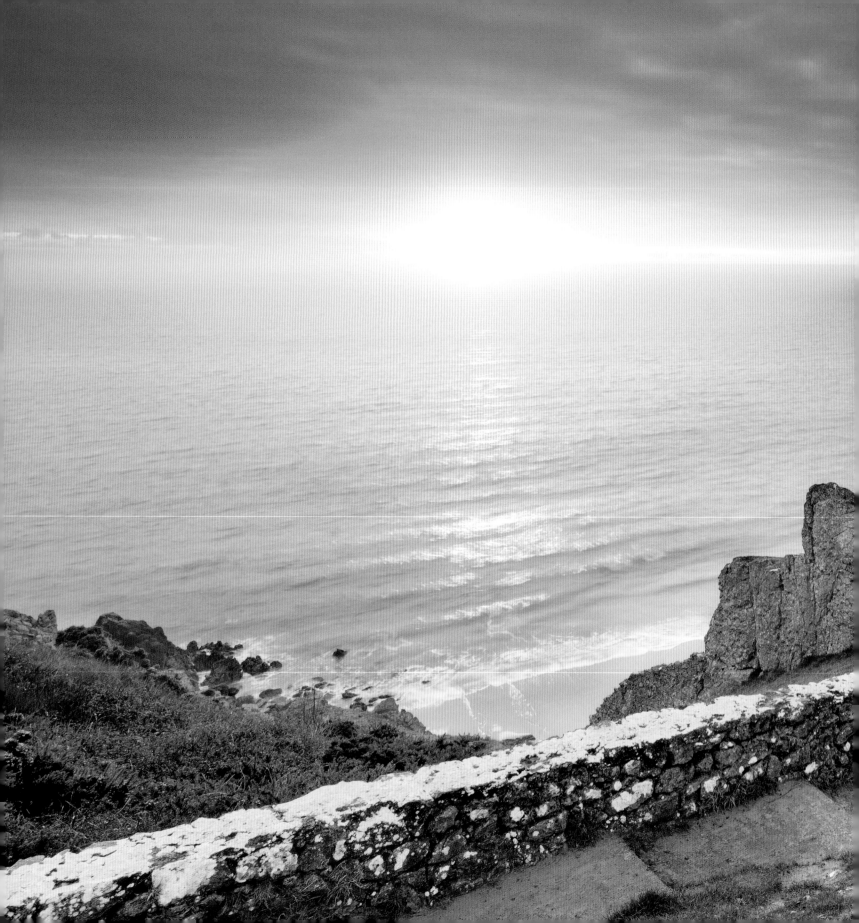

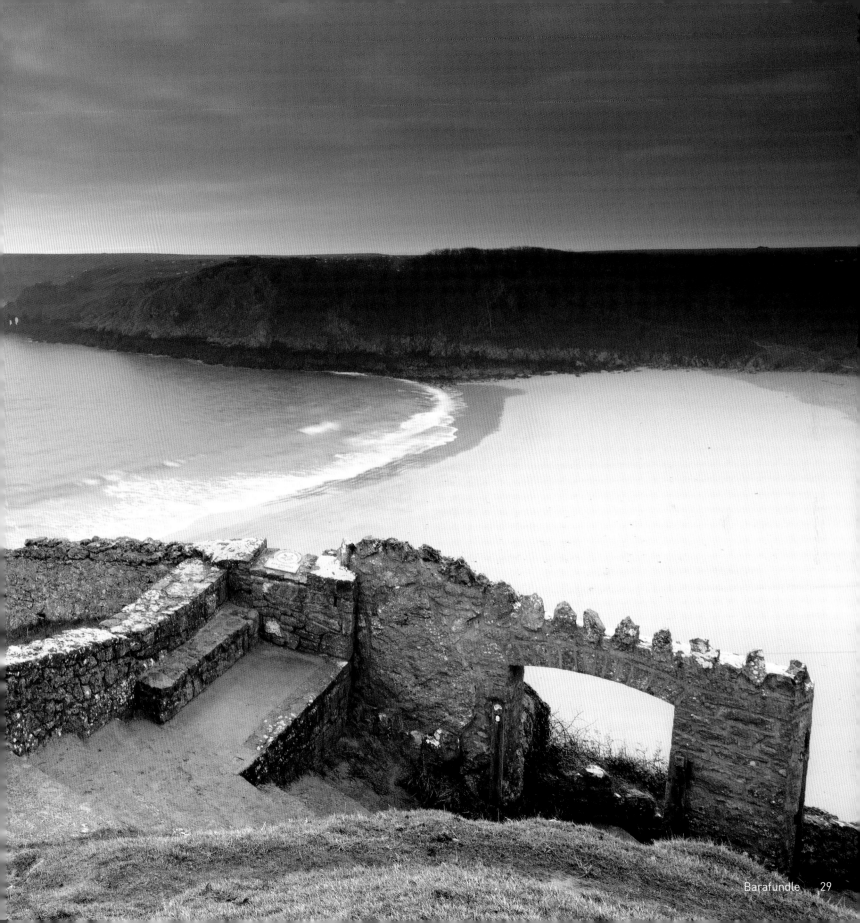

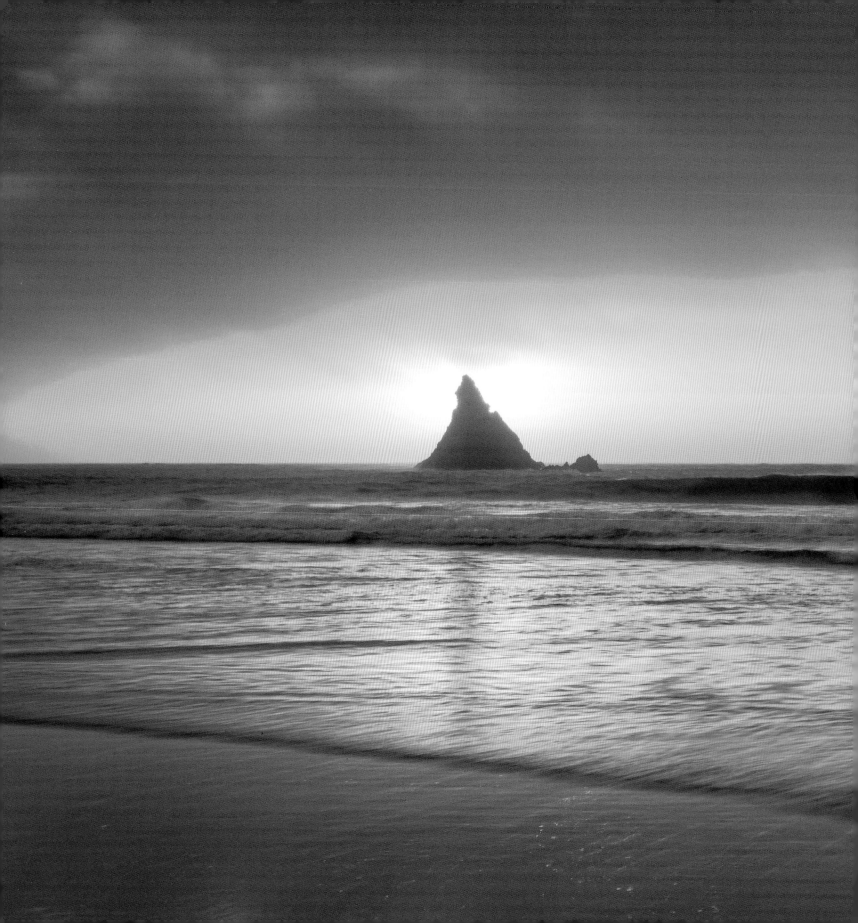

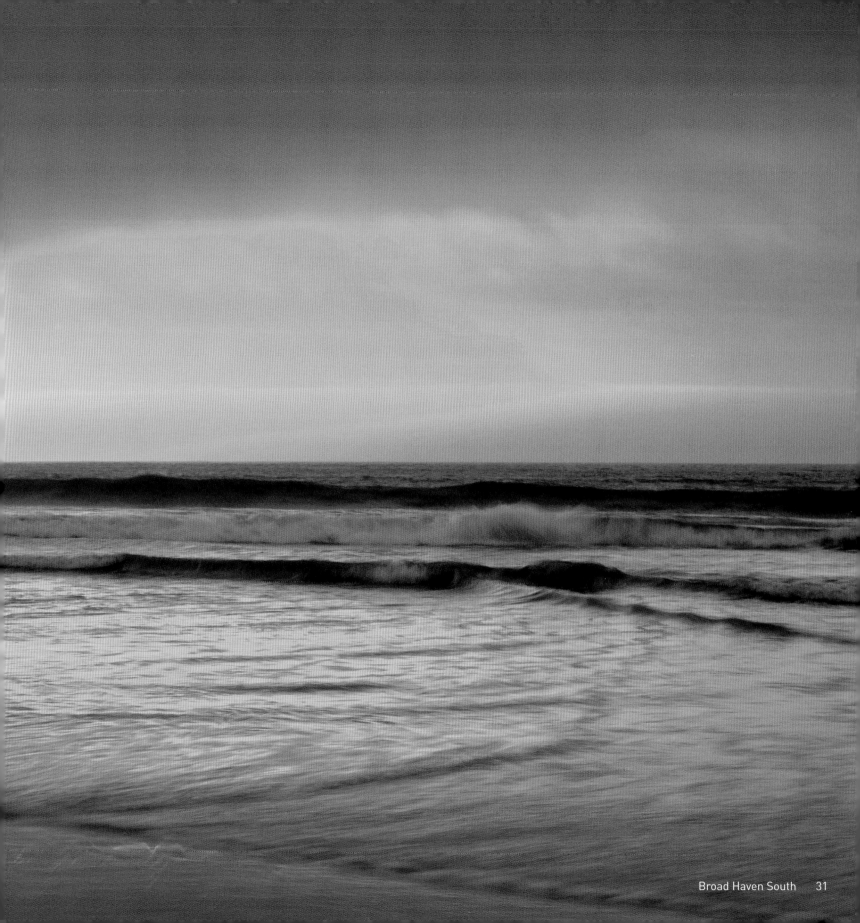

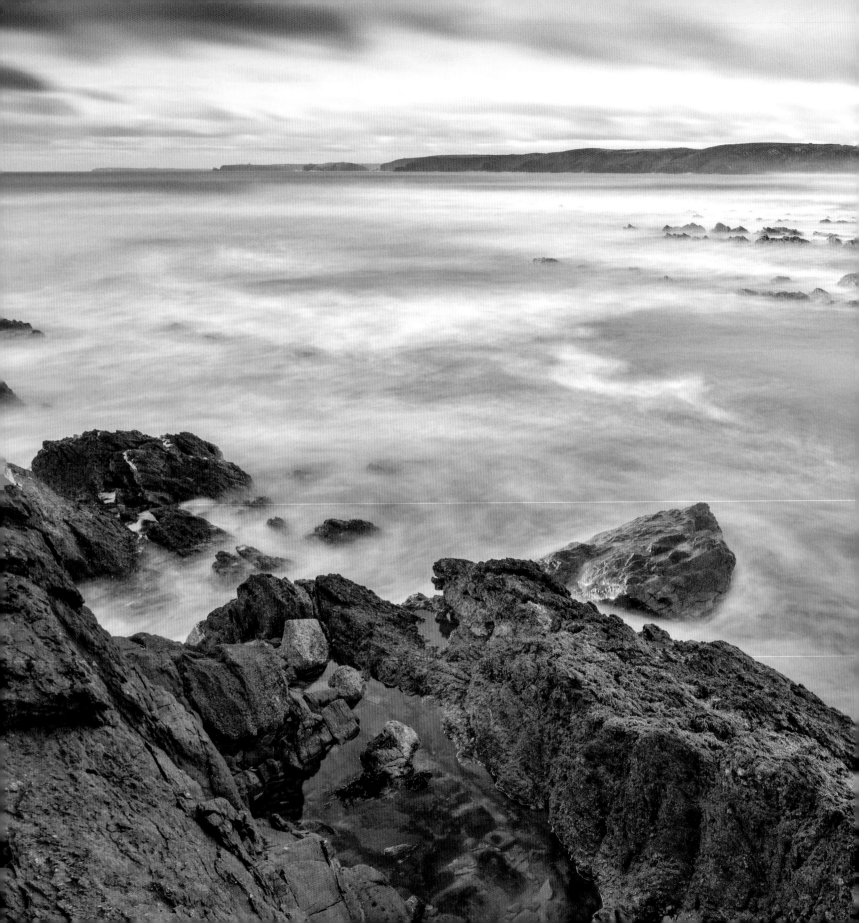

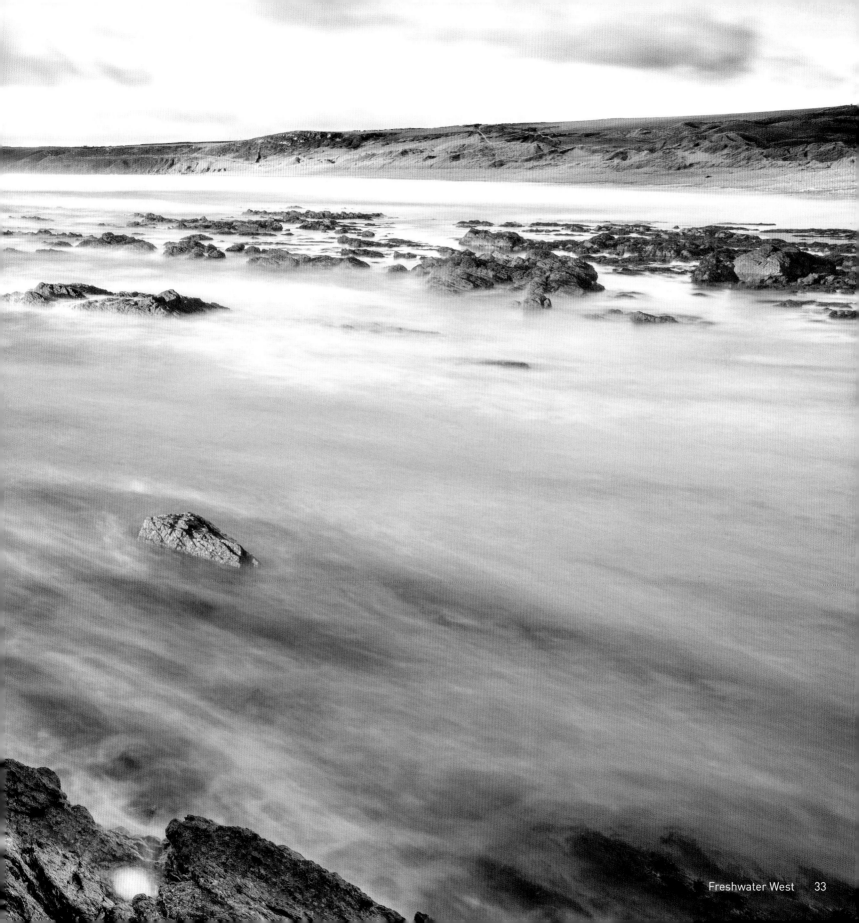

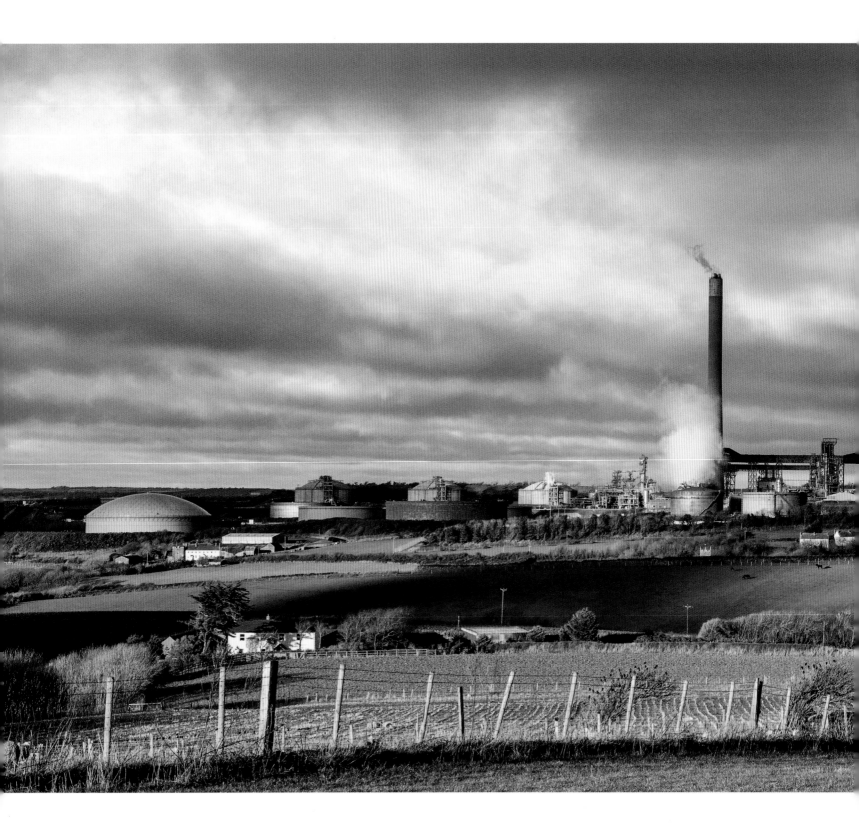

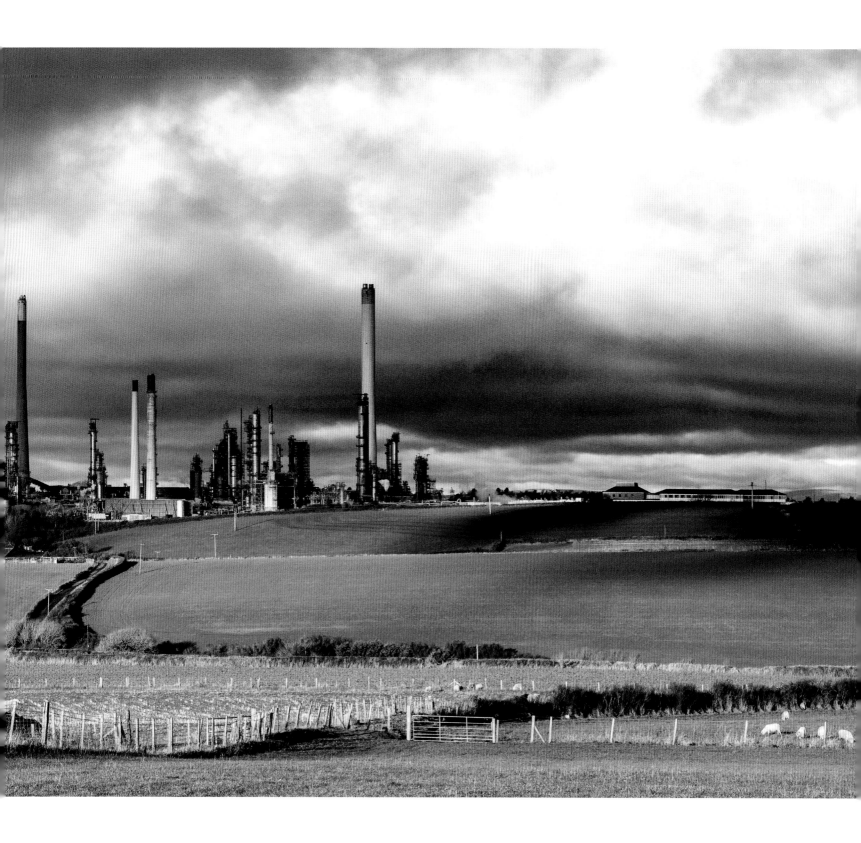

WEST PEMBROKESHIRE

WALES

26 St David's Head

25 Whitesands **23** St Non's

24 Porthselau

21 Between Newgale and Solva

22 St Brides Bay

19, 20 Newgale

18 Druidston Haven

17 Broad Haven

16 Marloes Sands

15 Short Point **14** Milford Haven

 Pembrokeshire National Park

© Crown Copyright 2015 OS 100050715.

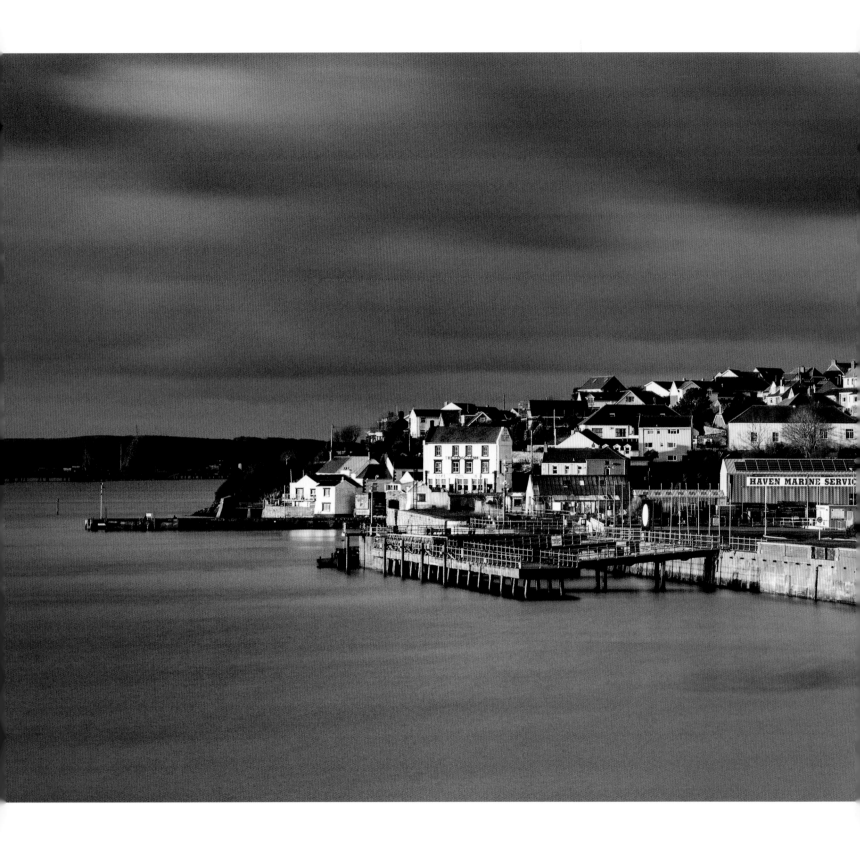

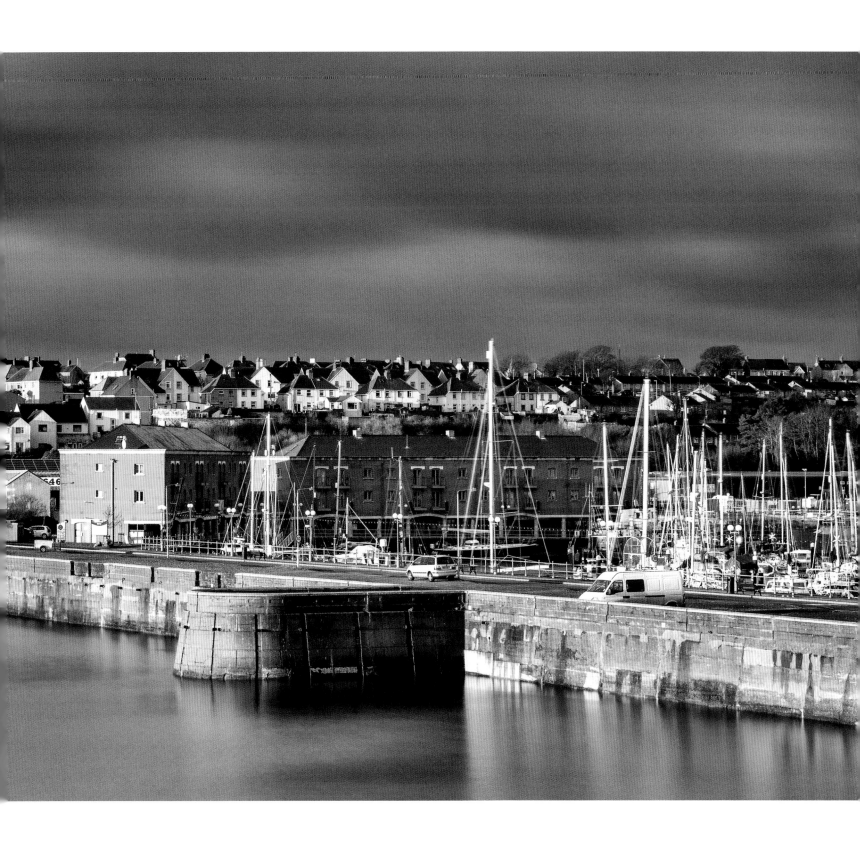

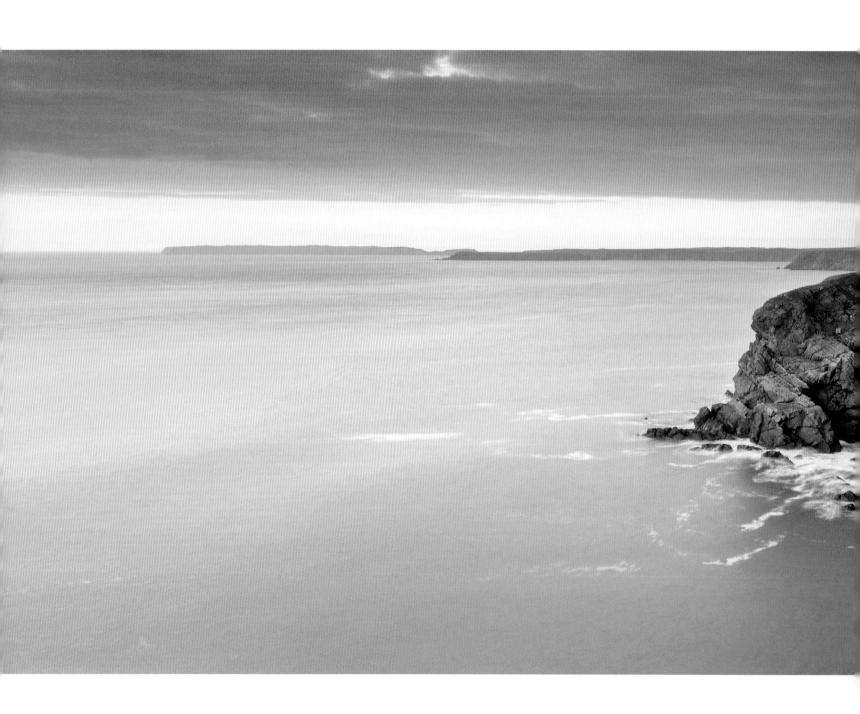

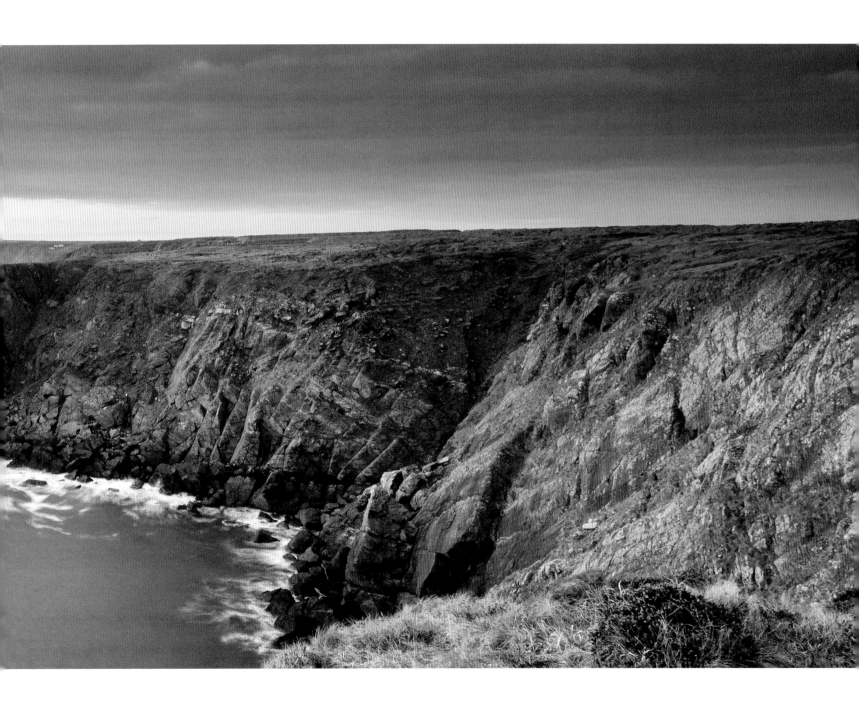

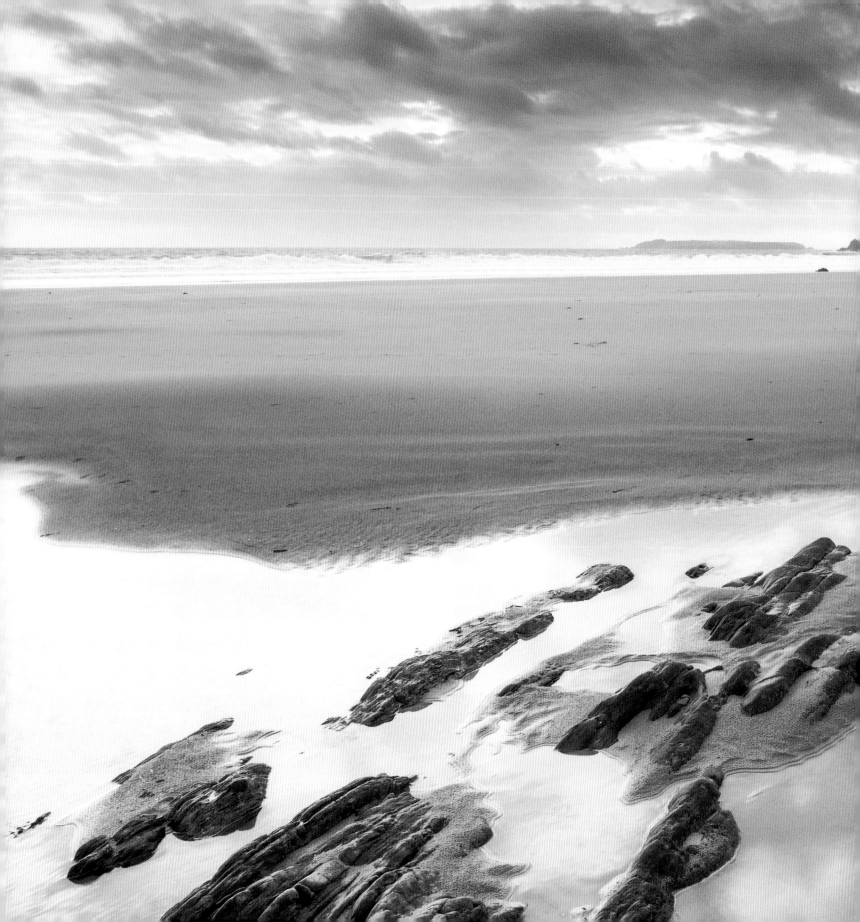

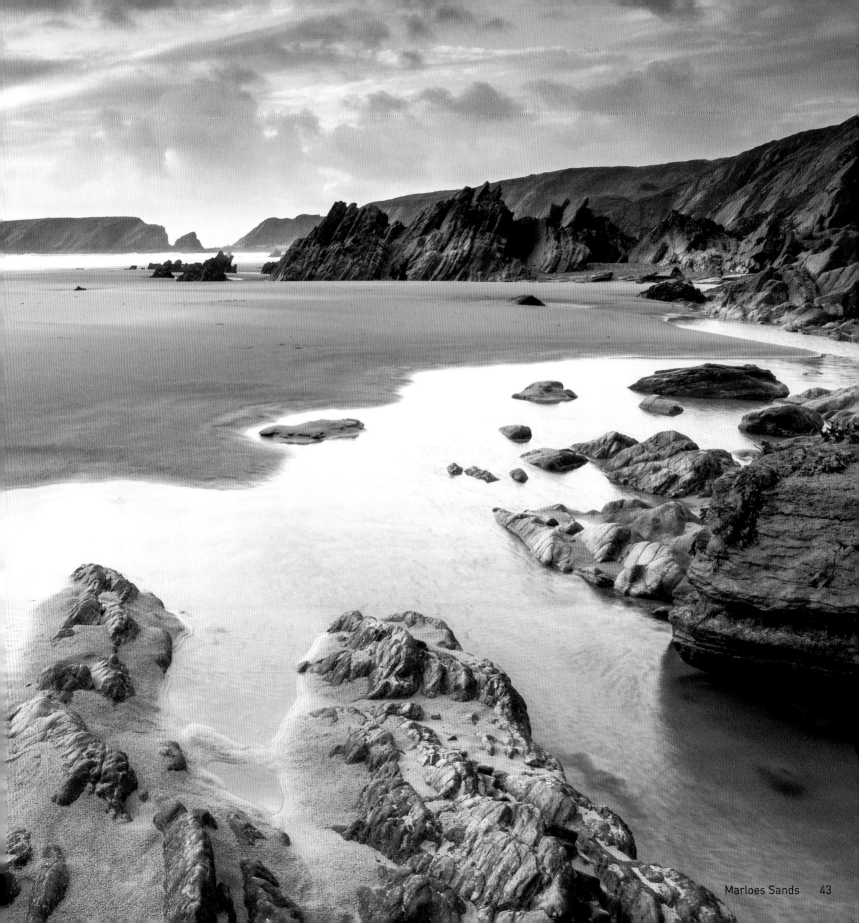

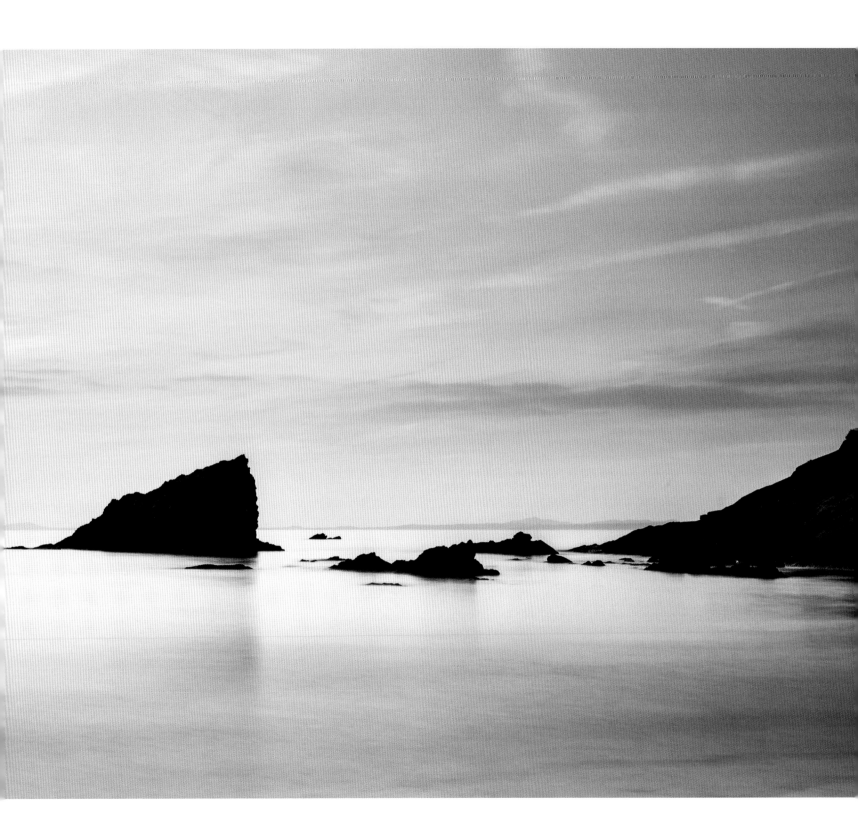

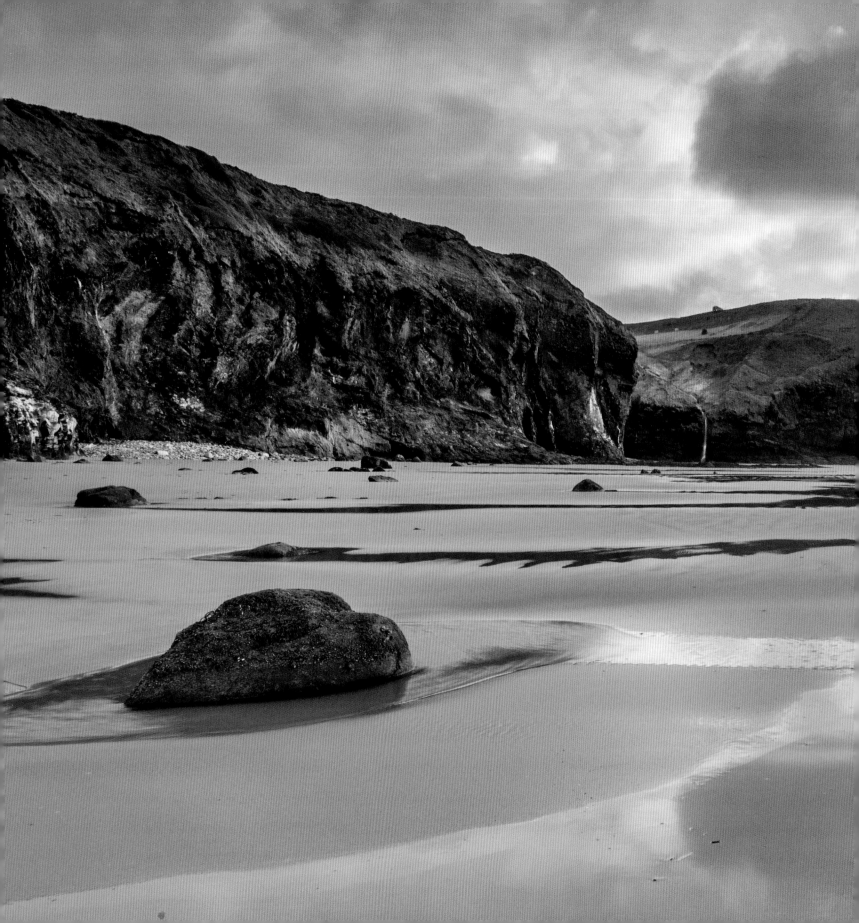

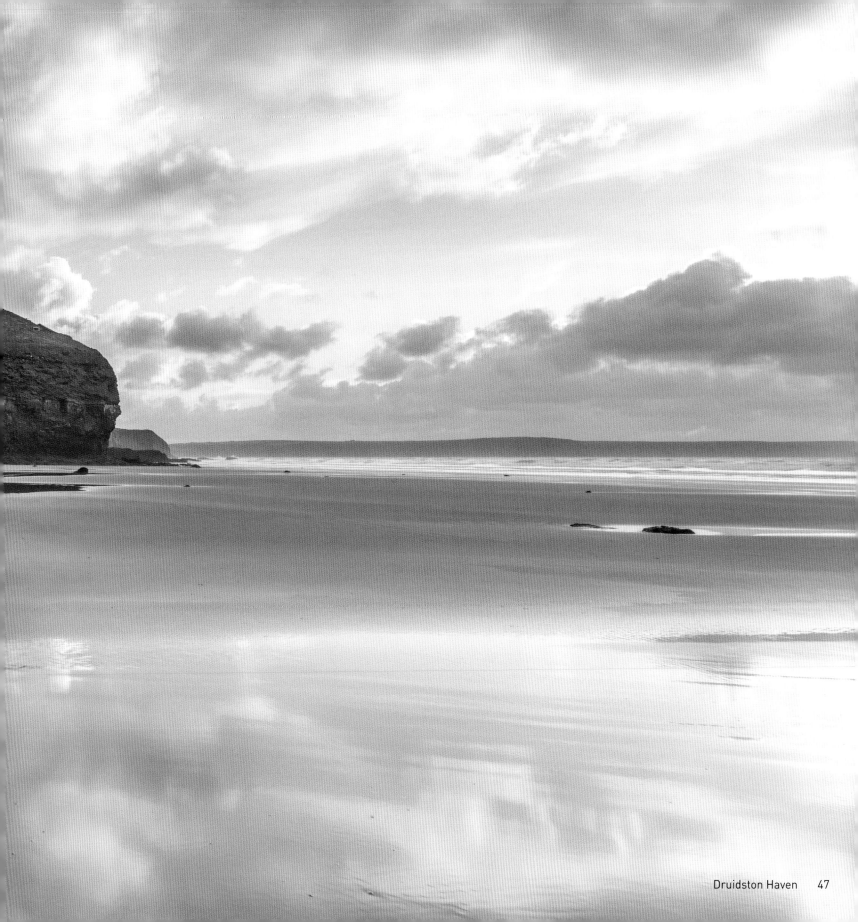

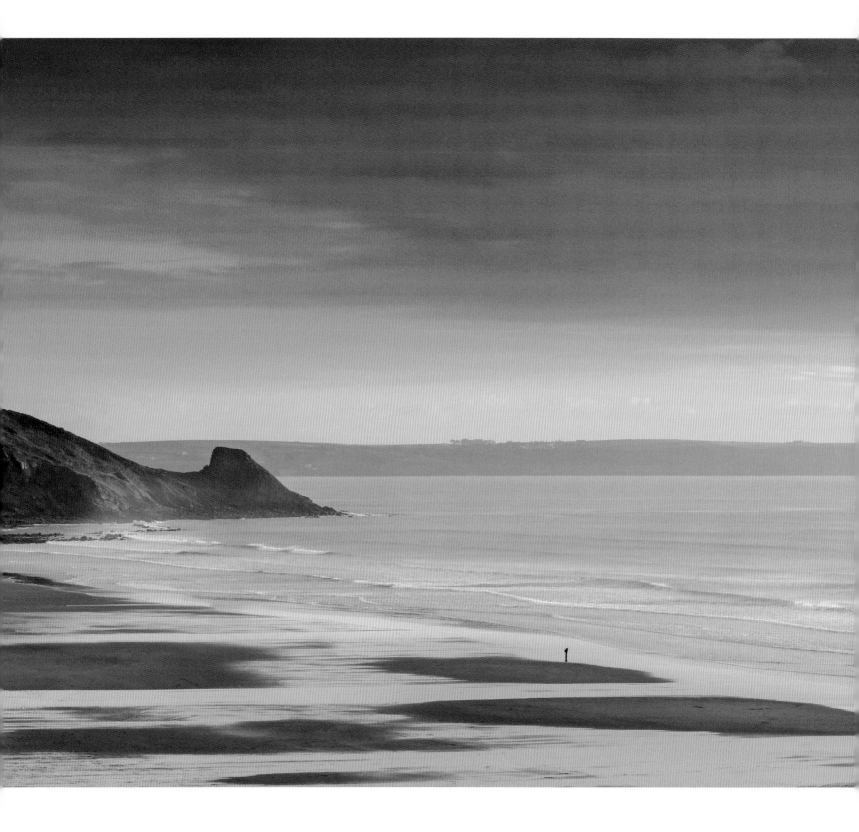

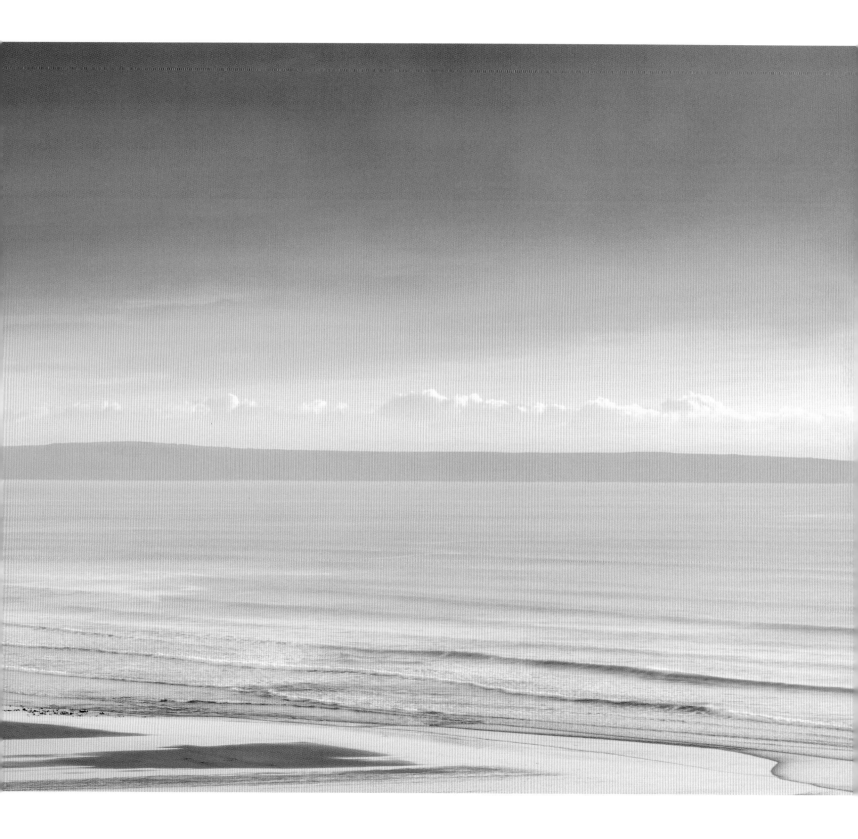

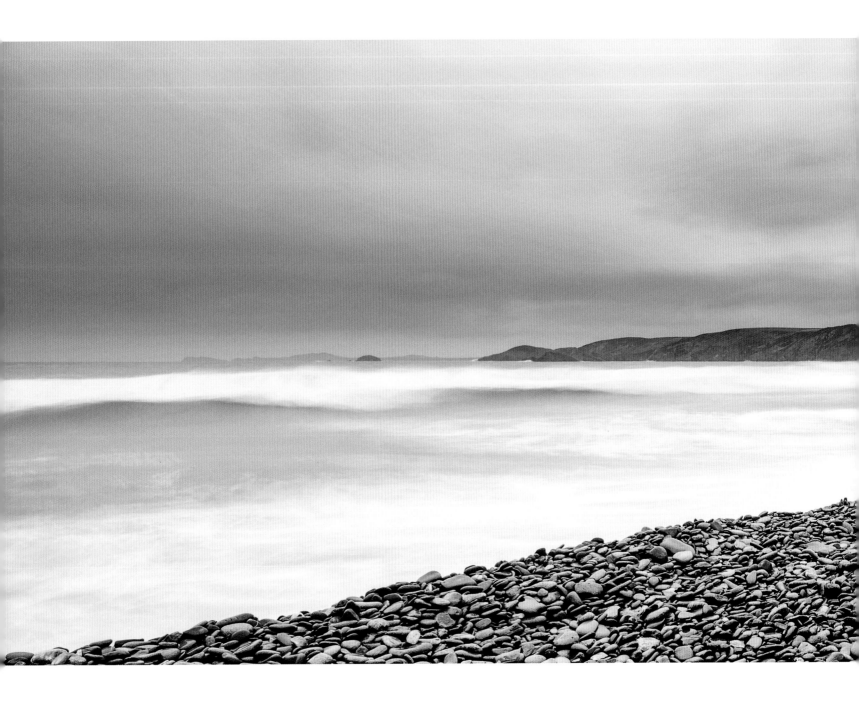

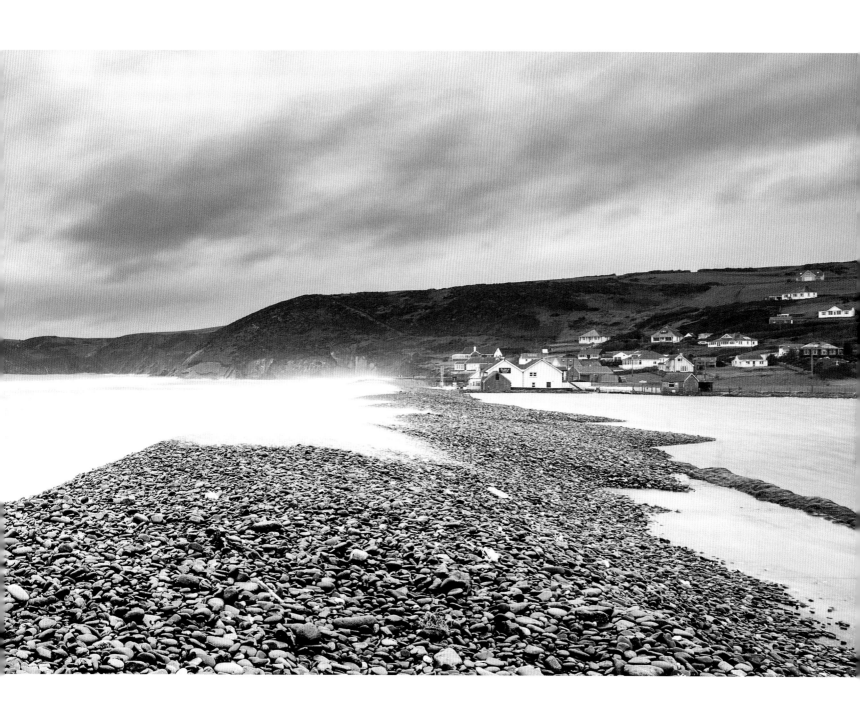

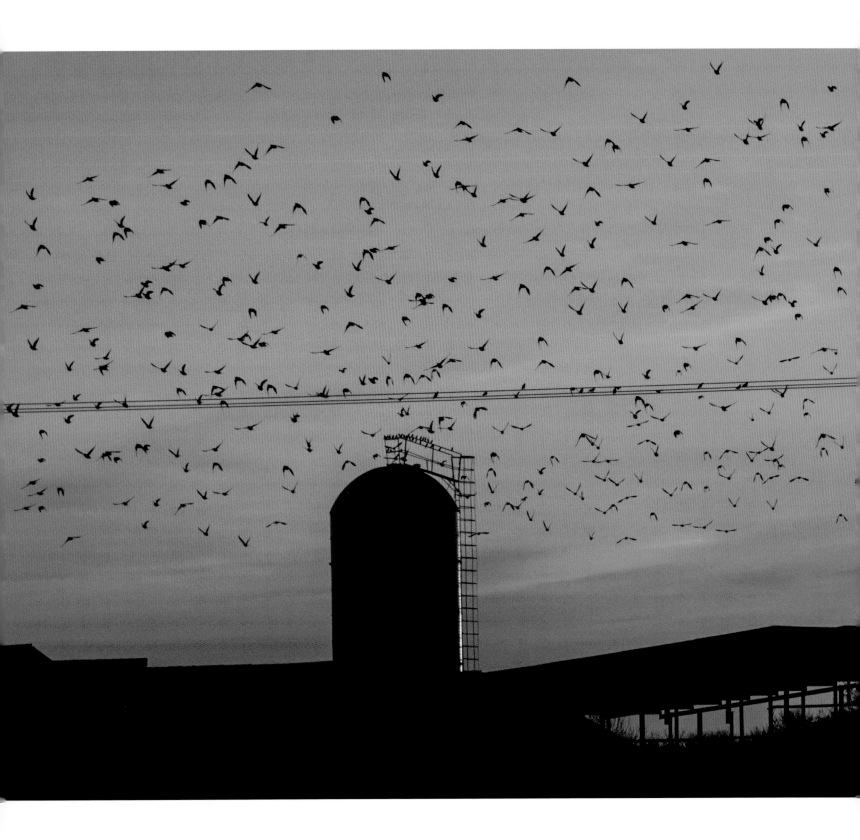

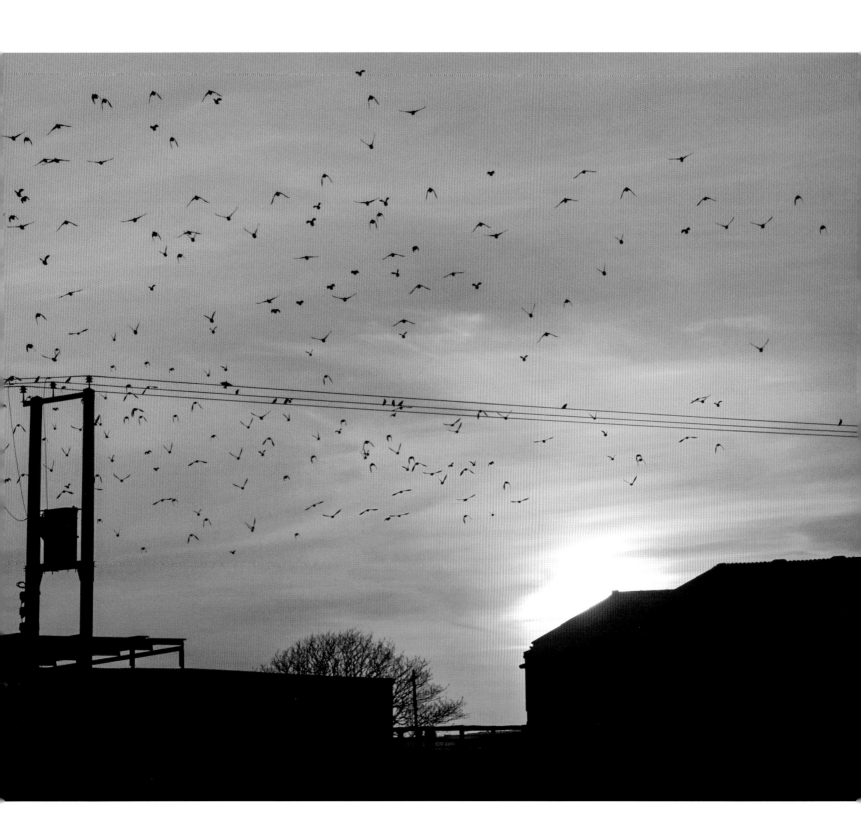

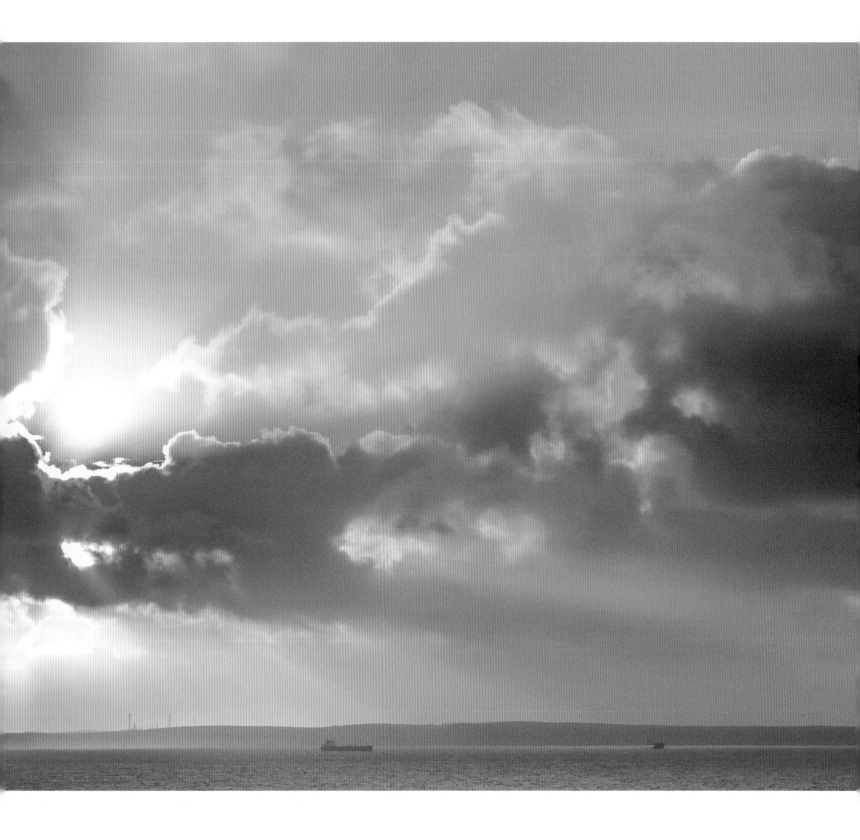

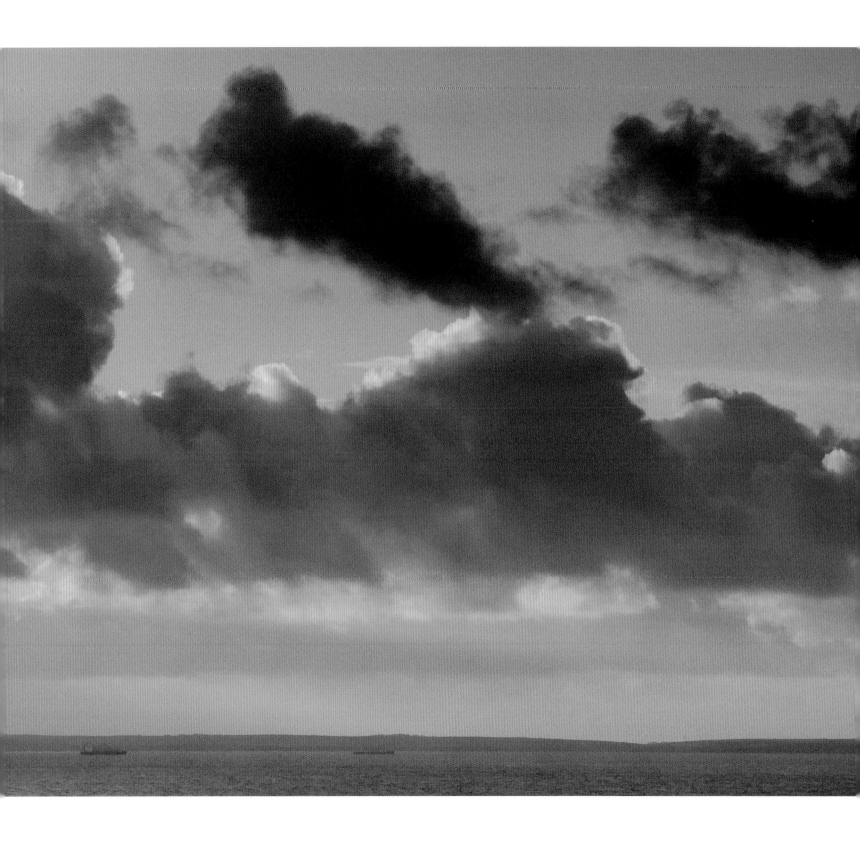

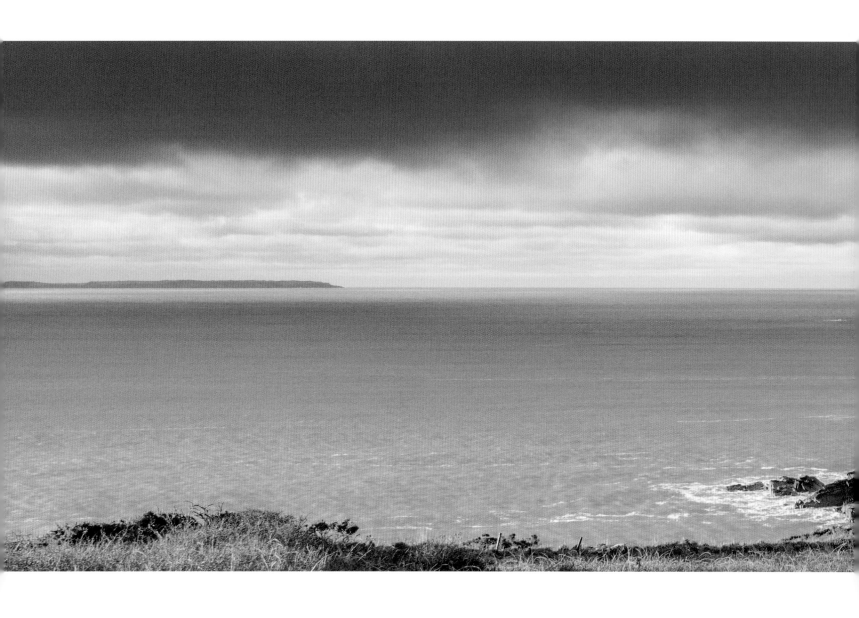

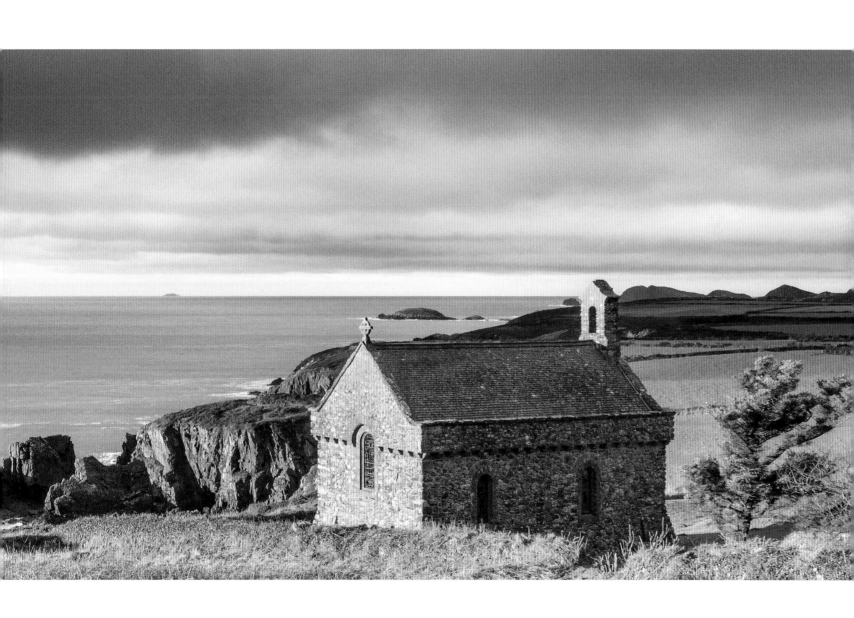

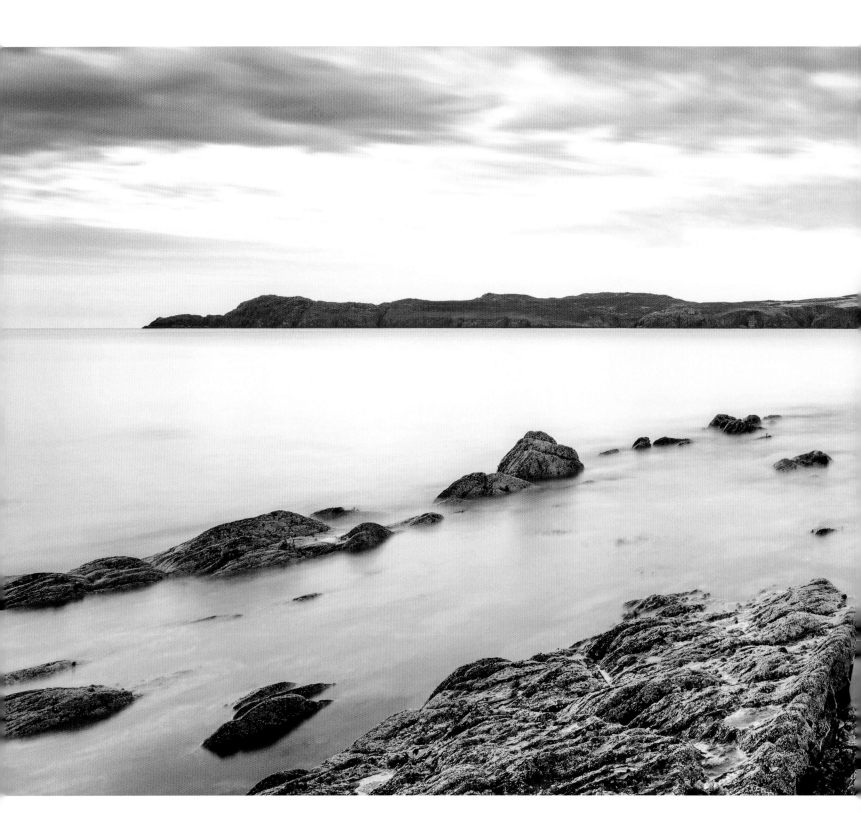

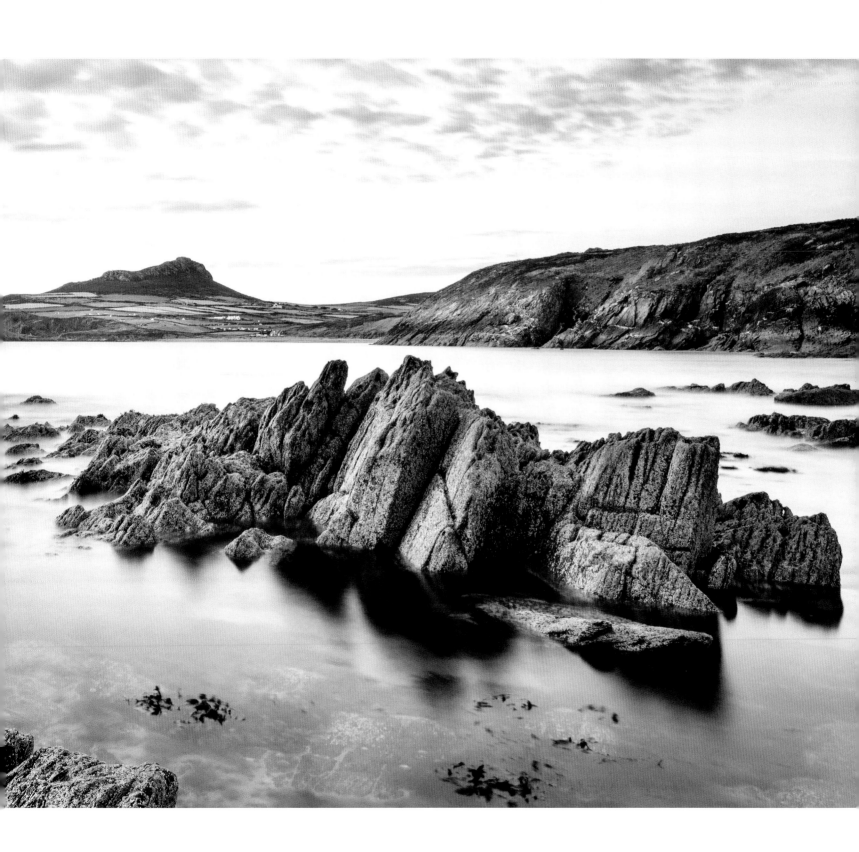

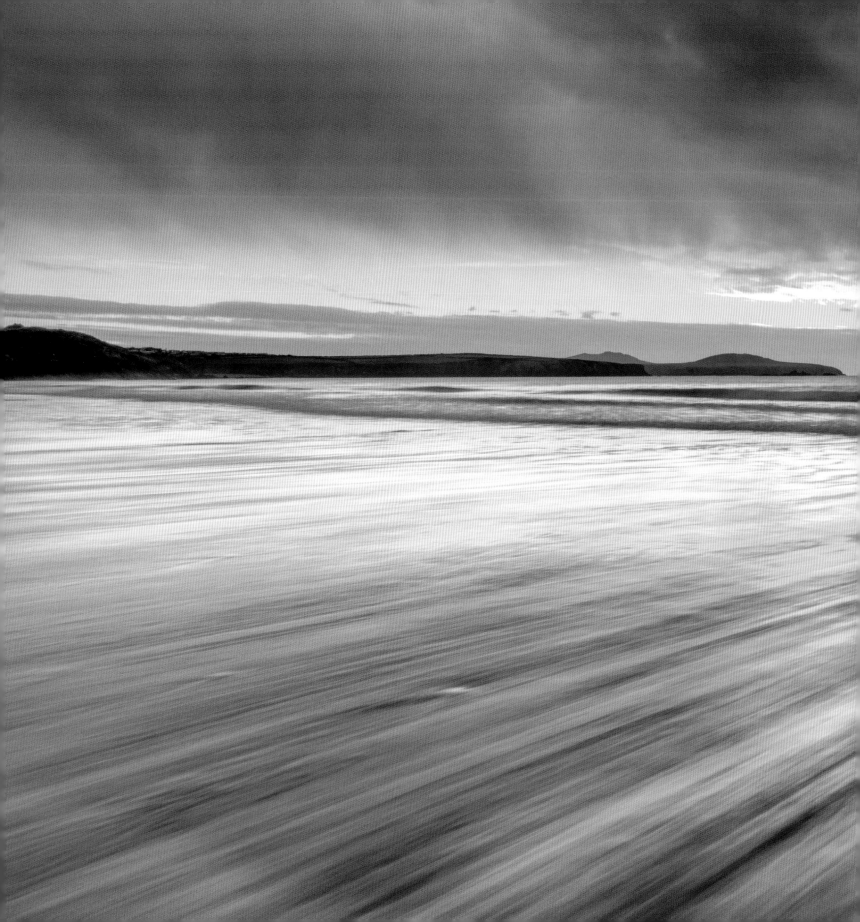

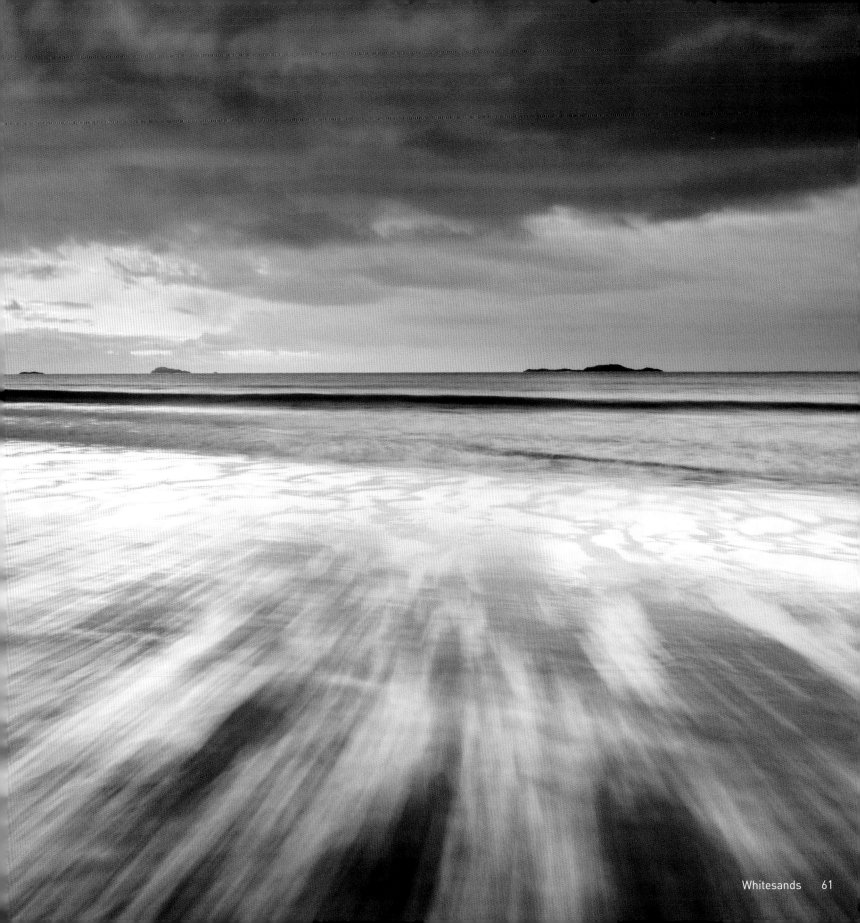

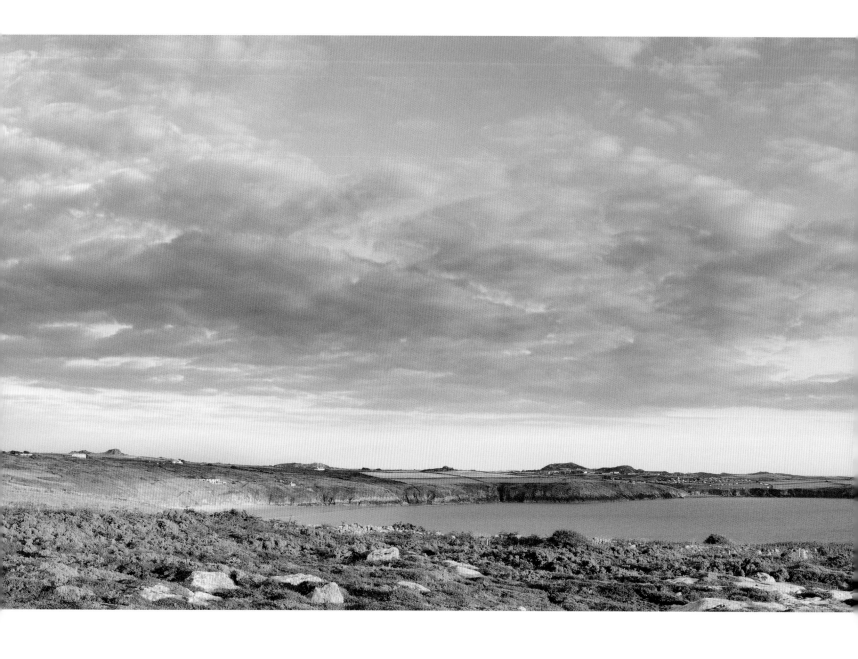

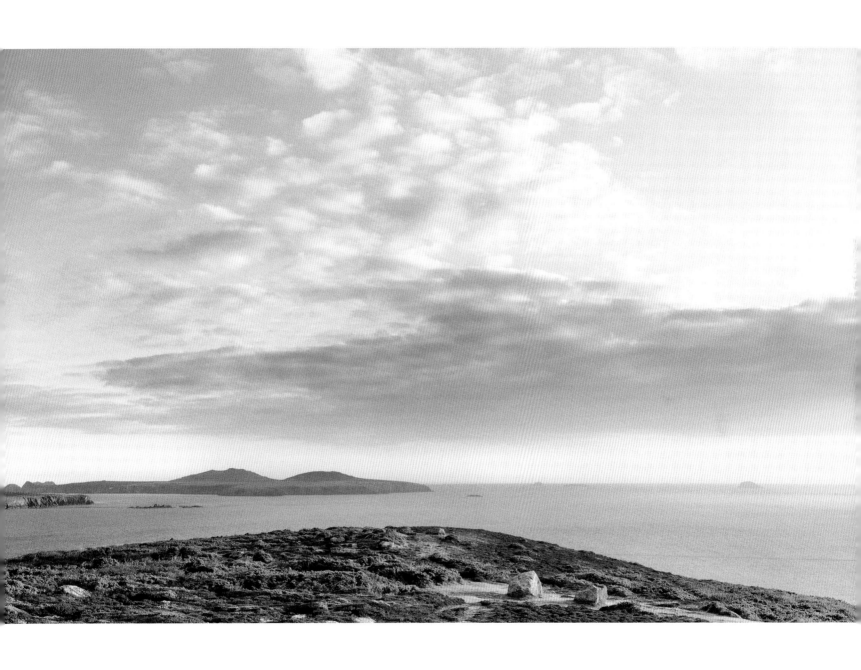

NORTH PEMBROKESHIRE

WALES

33 Strumble Head Lighthouse

38 Ceibwr Bay

37 Nevern Estuary

36 Parrog, Newport

41 Overlooking Dinas Head, Preselis

40 Carn Enoch

34 Goodwick

35 Aberfforest

39 Overlooking
Goodwick

32 Aberbach

31 Near Abercastle

29 Aber Draw

30 Mathry

28 Traeth Llyfn

27 Abereiddy

Pembrokeshire National Park

© Crown Copyright 2015 OS 100050715.

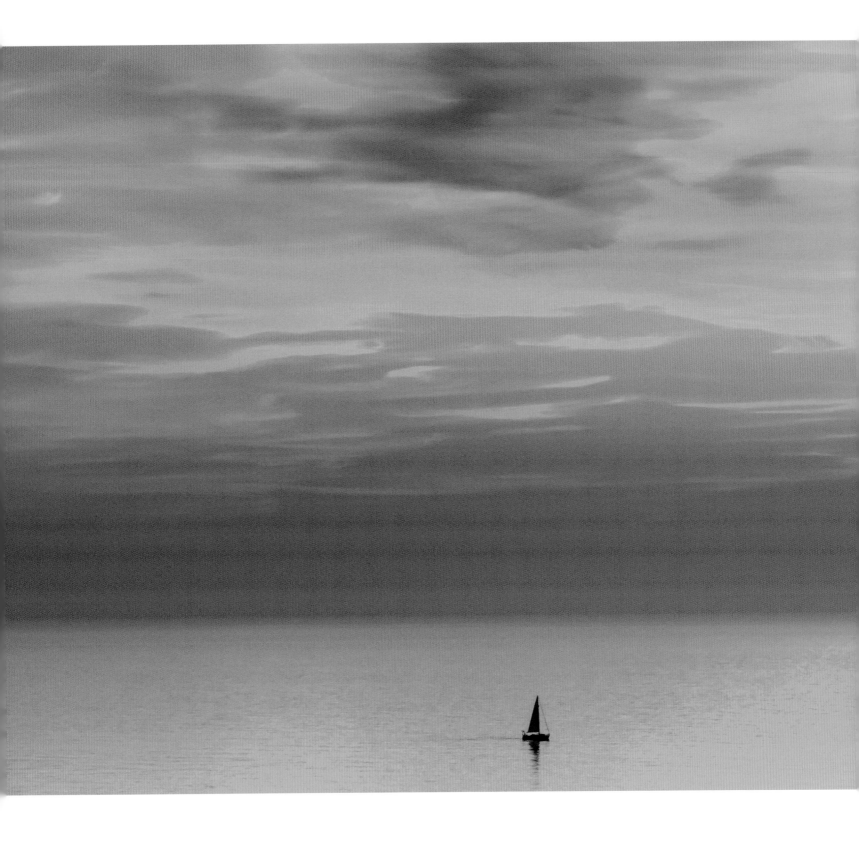

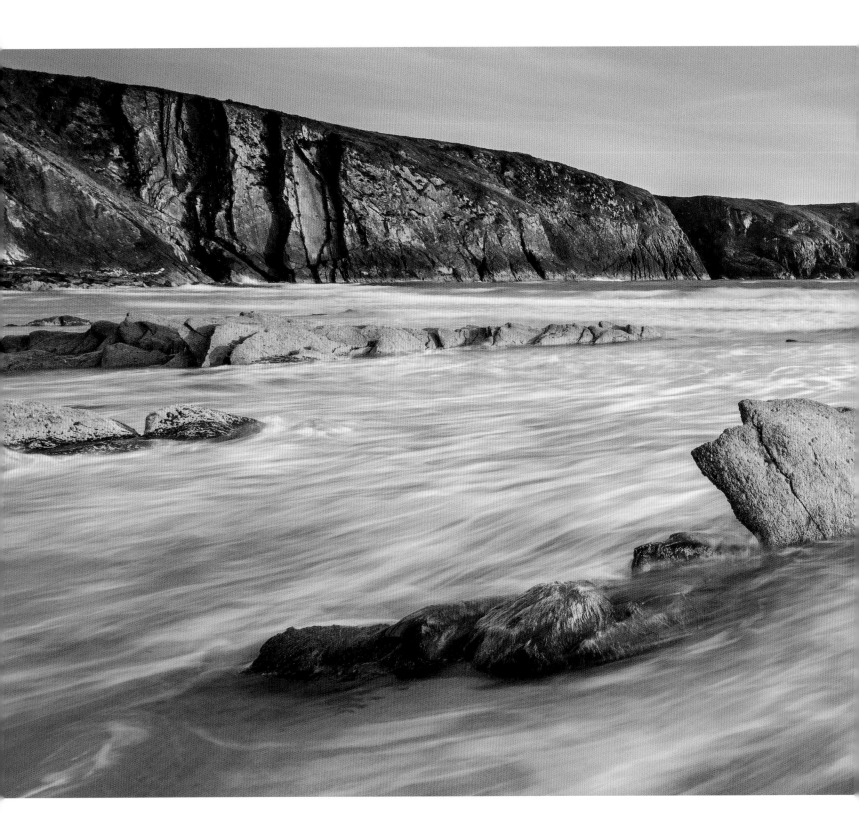

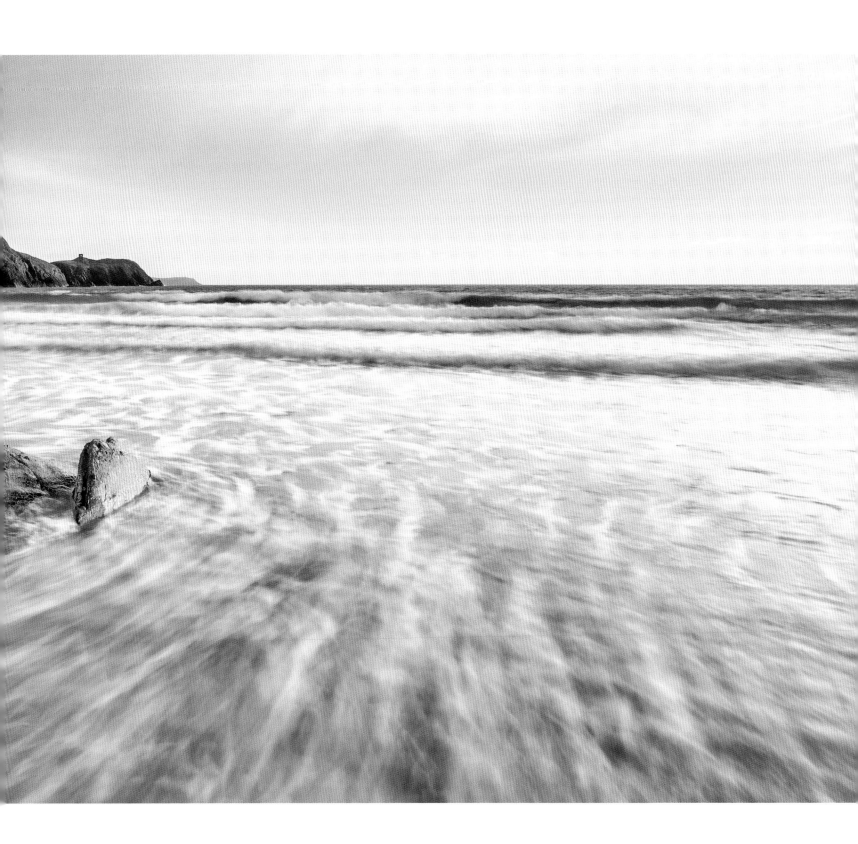

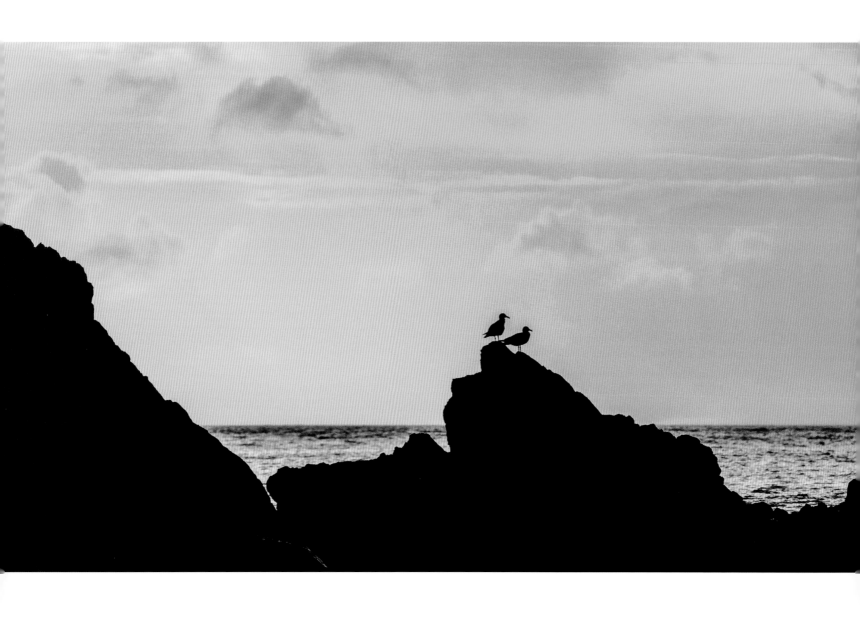

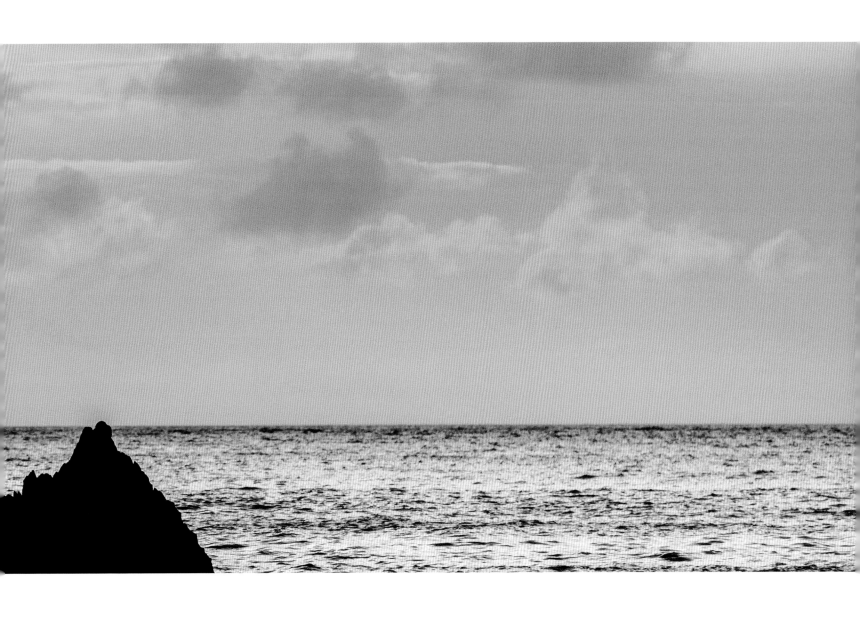

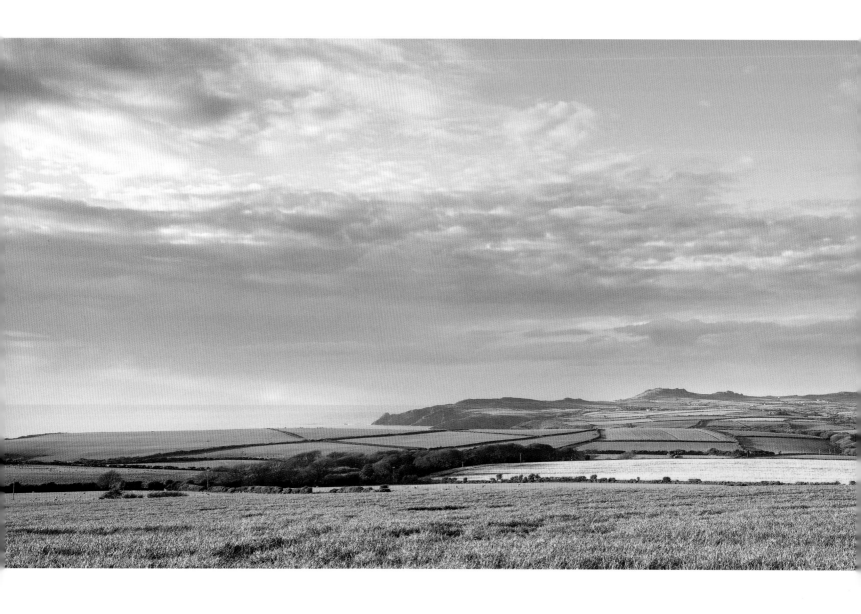

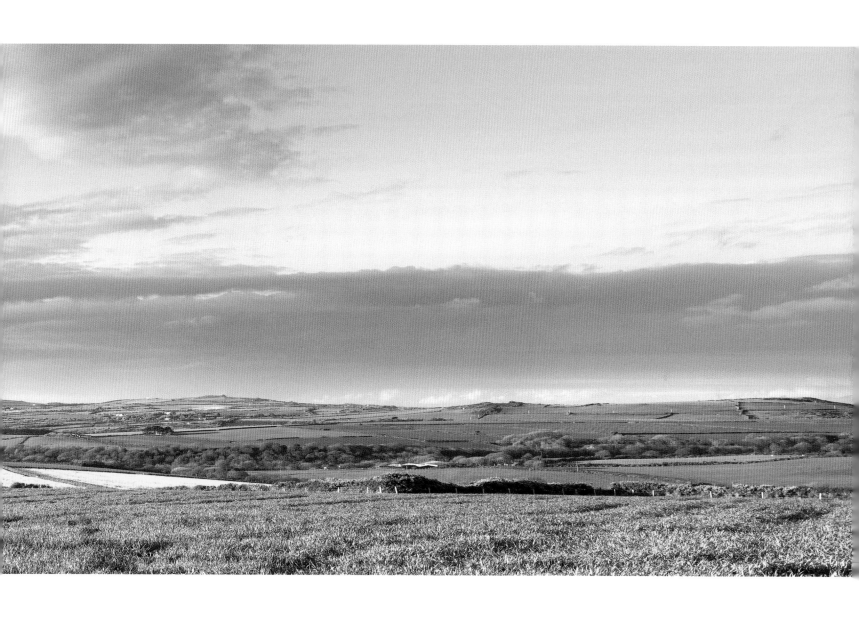

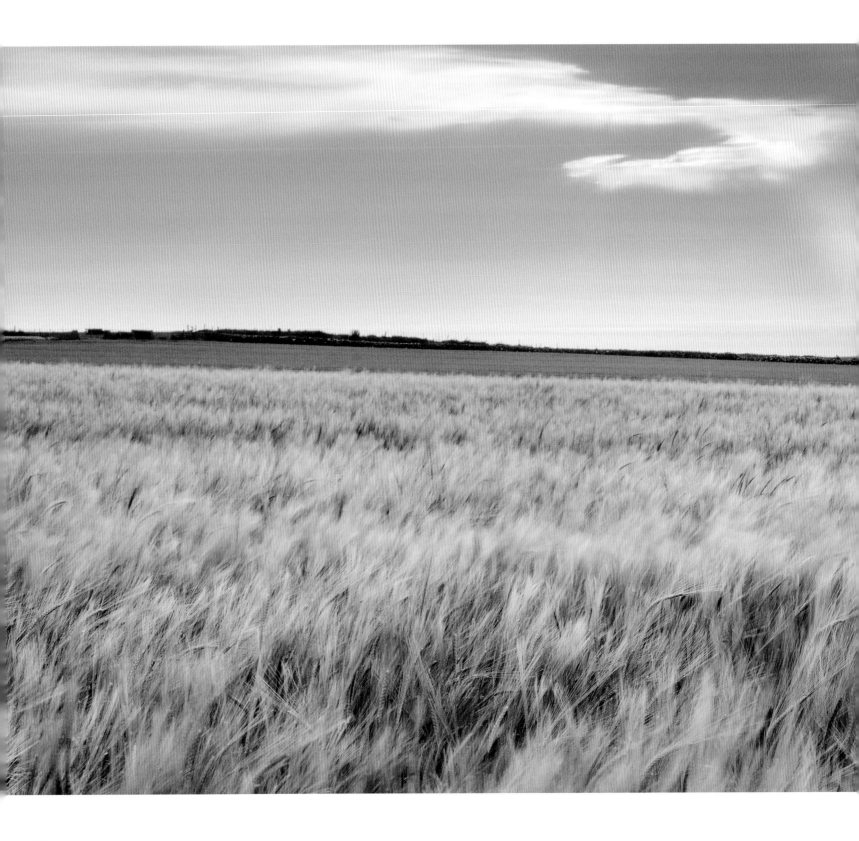

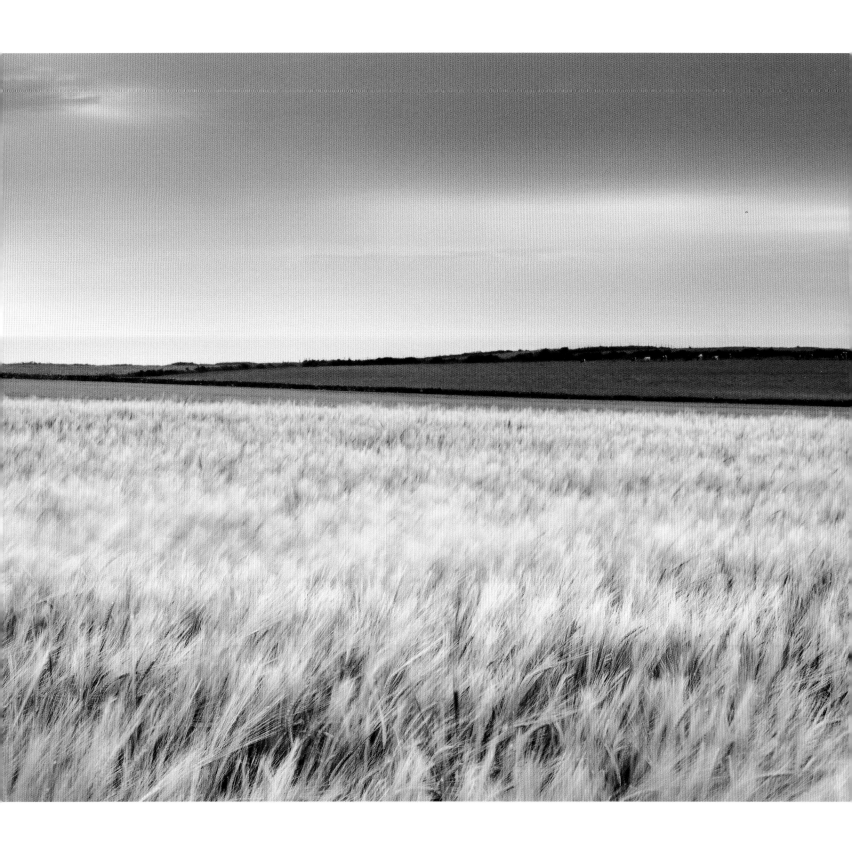

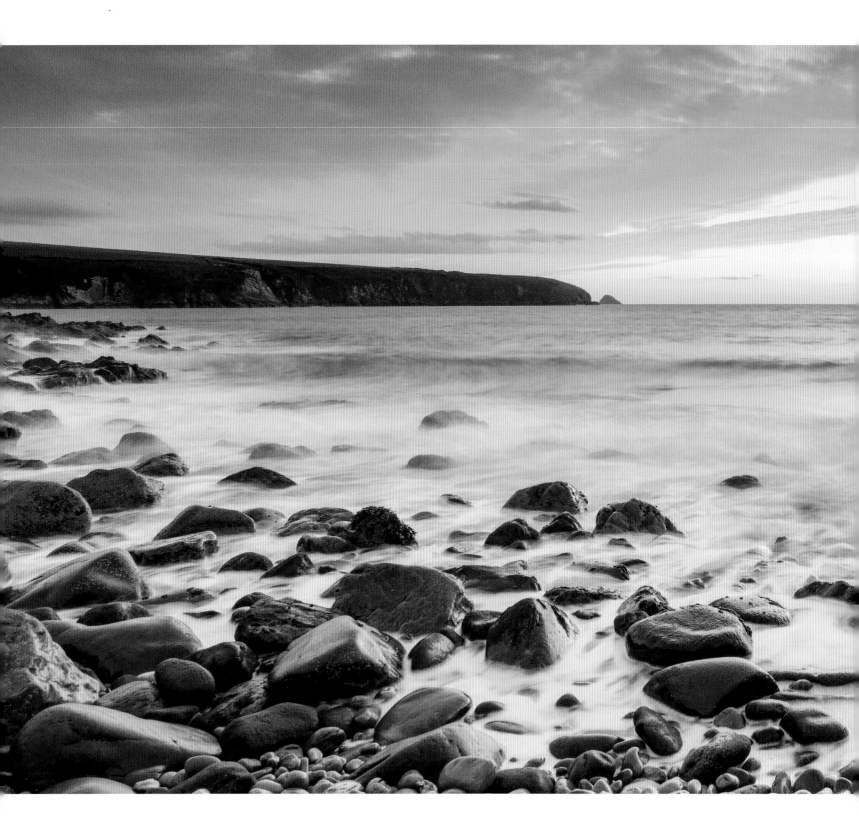

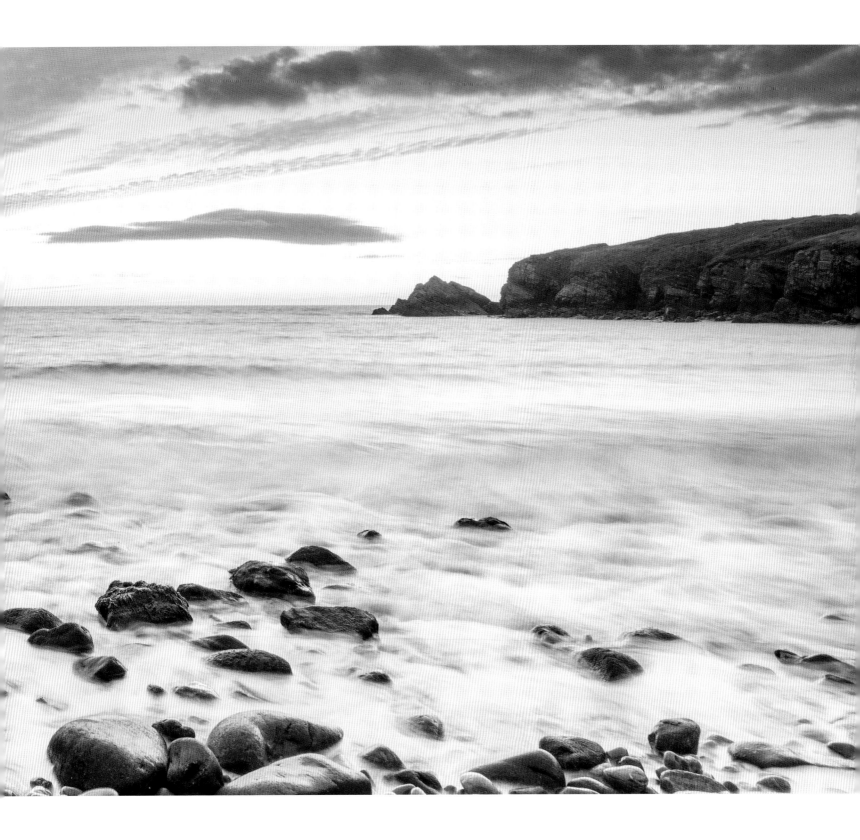

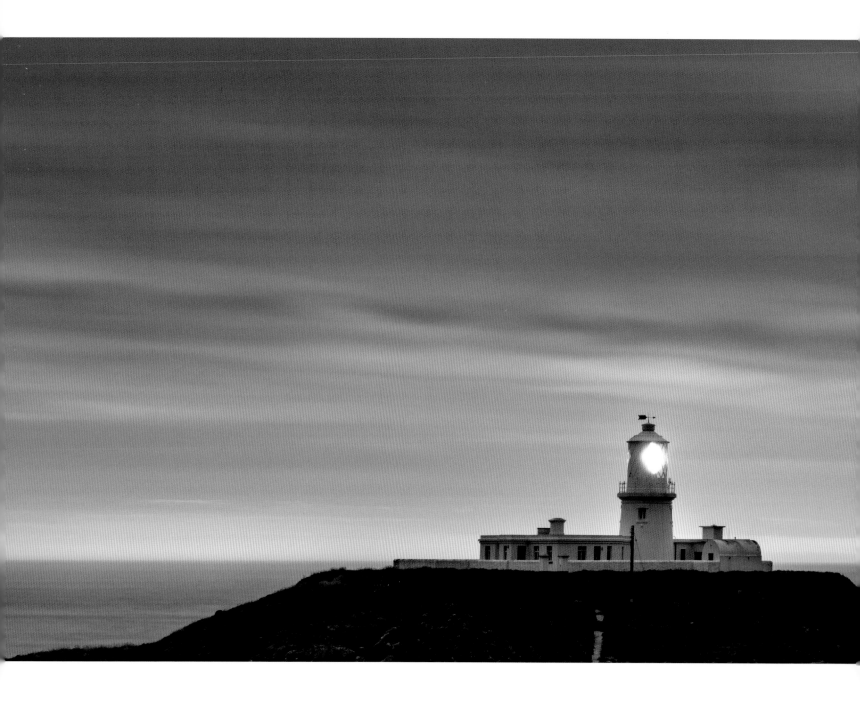

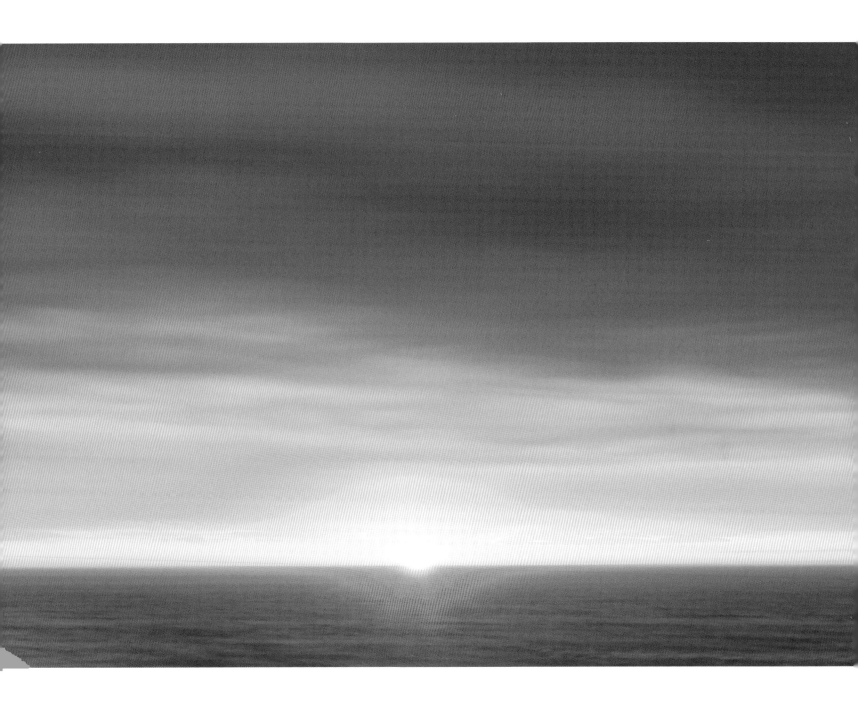

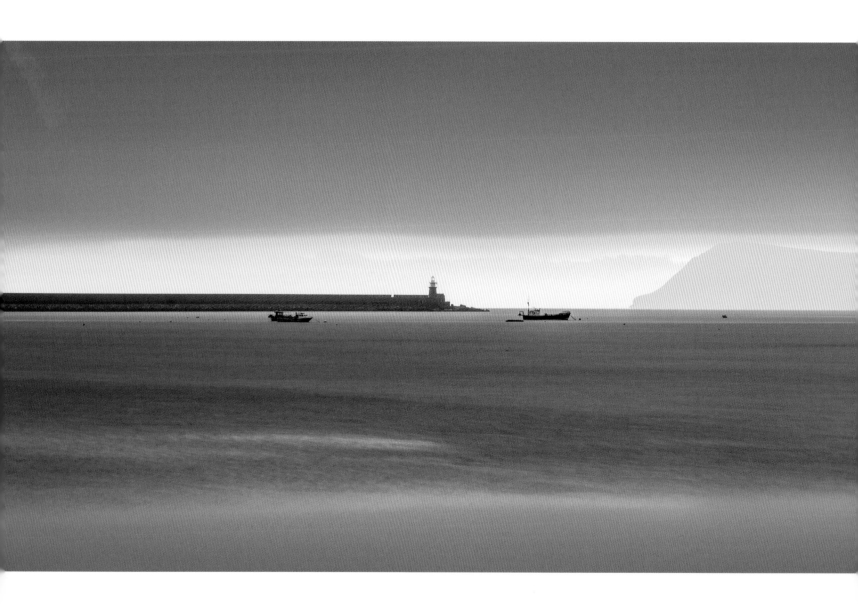

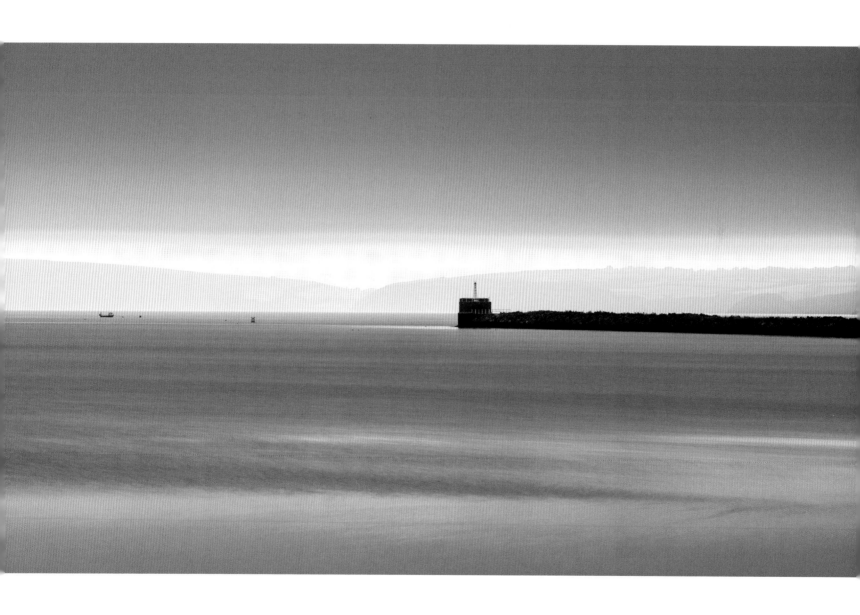

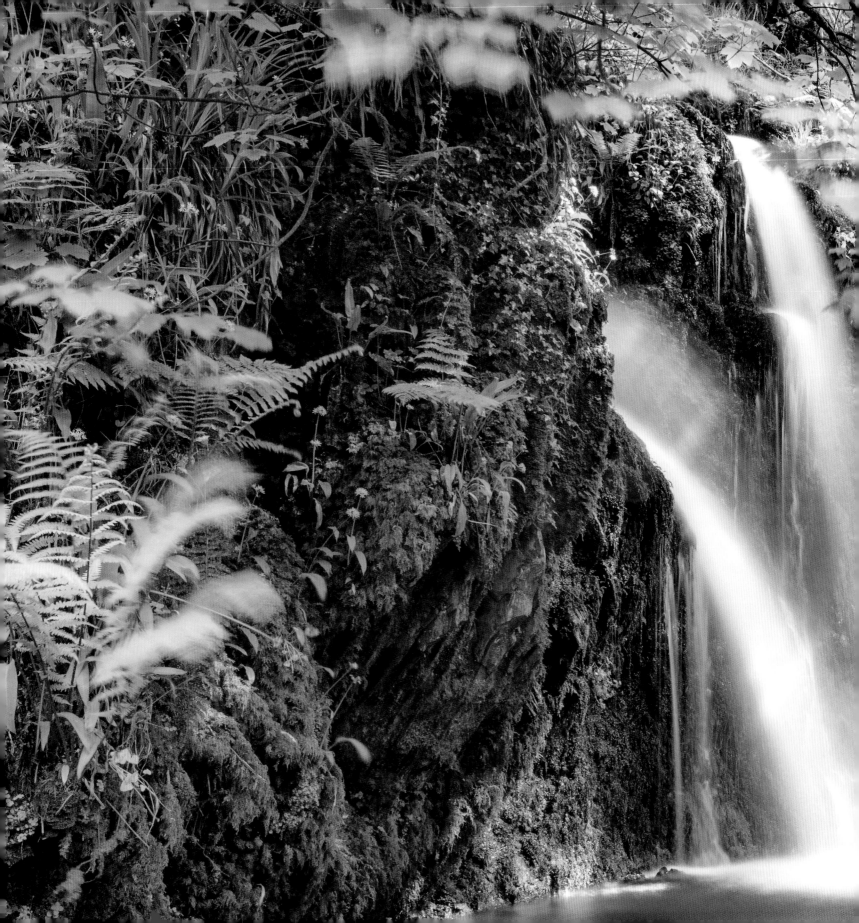

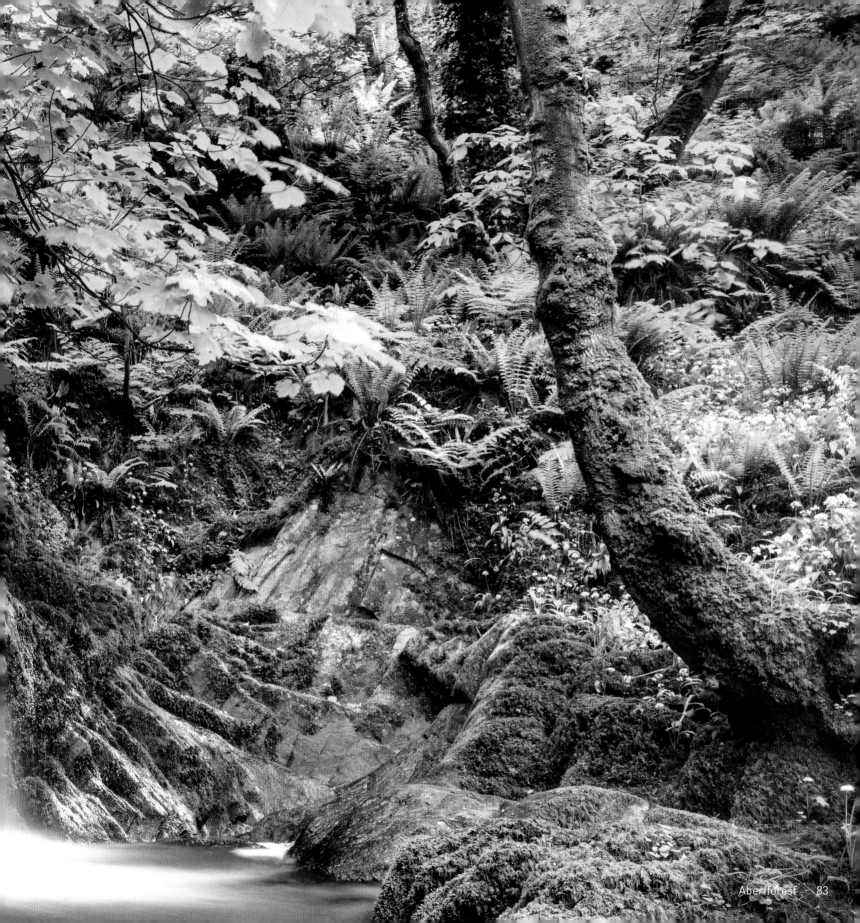

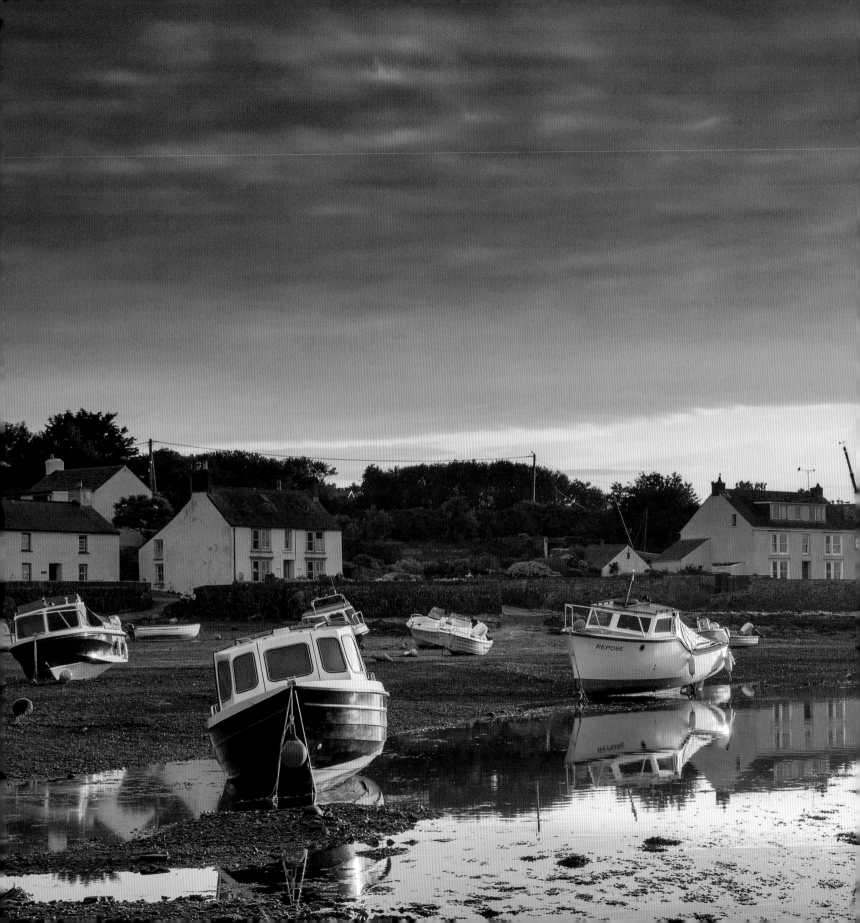

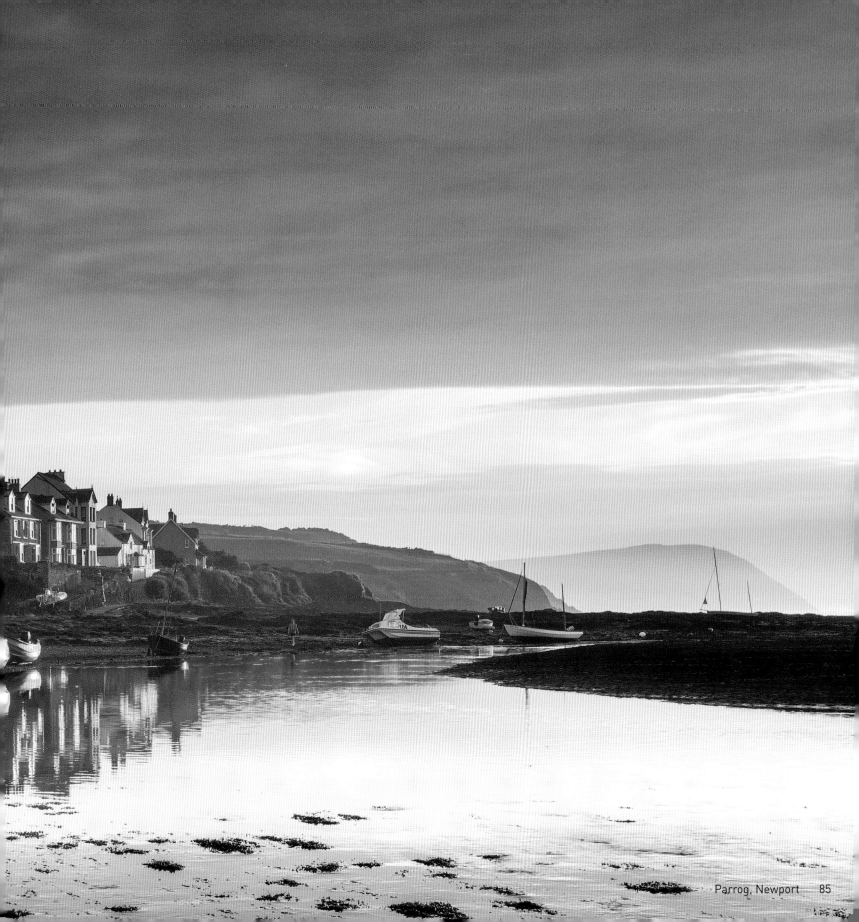

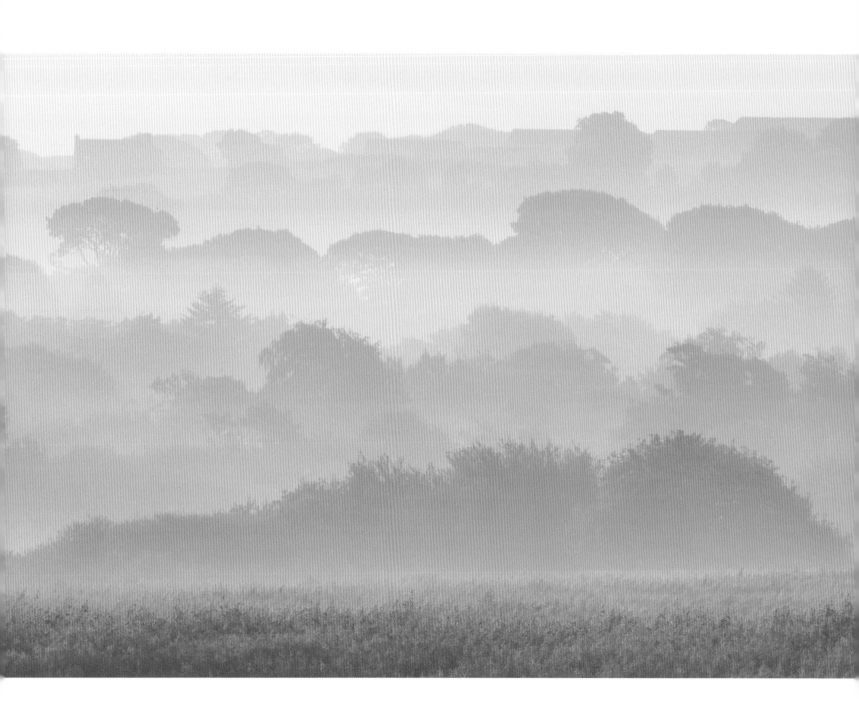

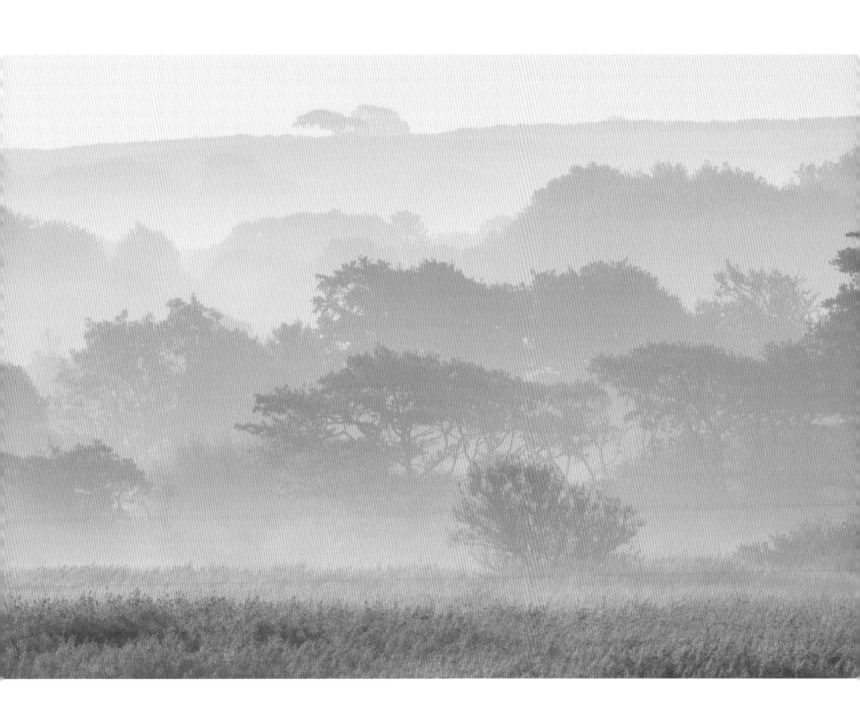

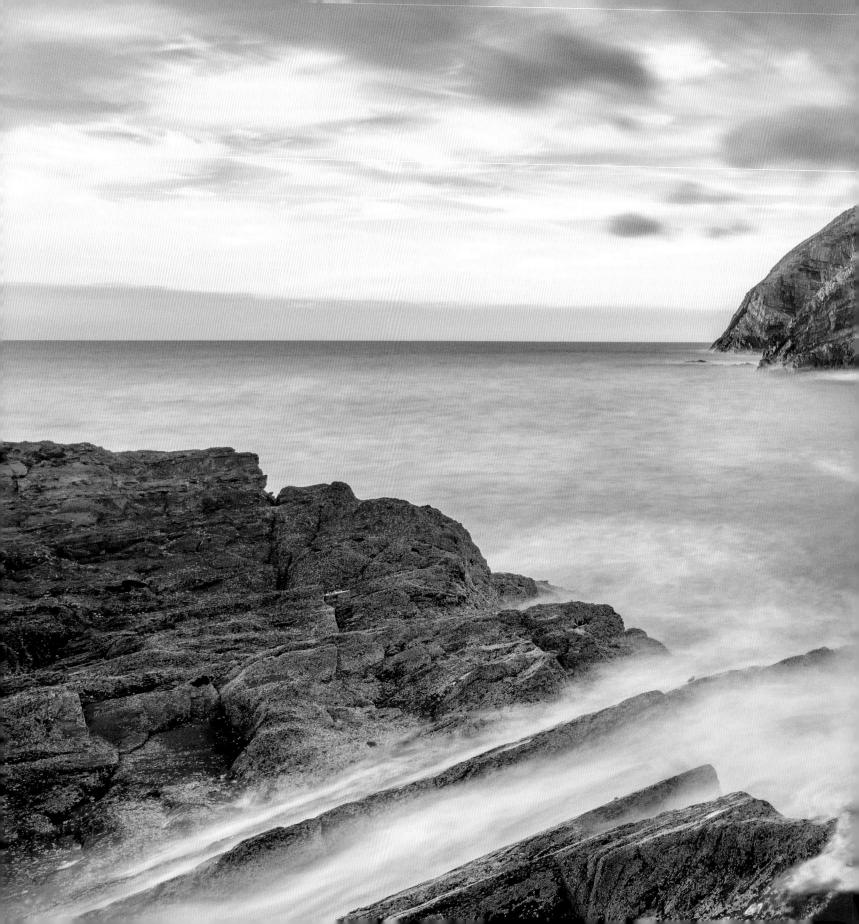

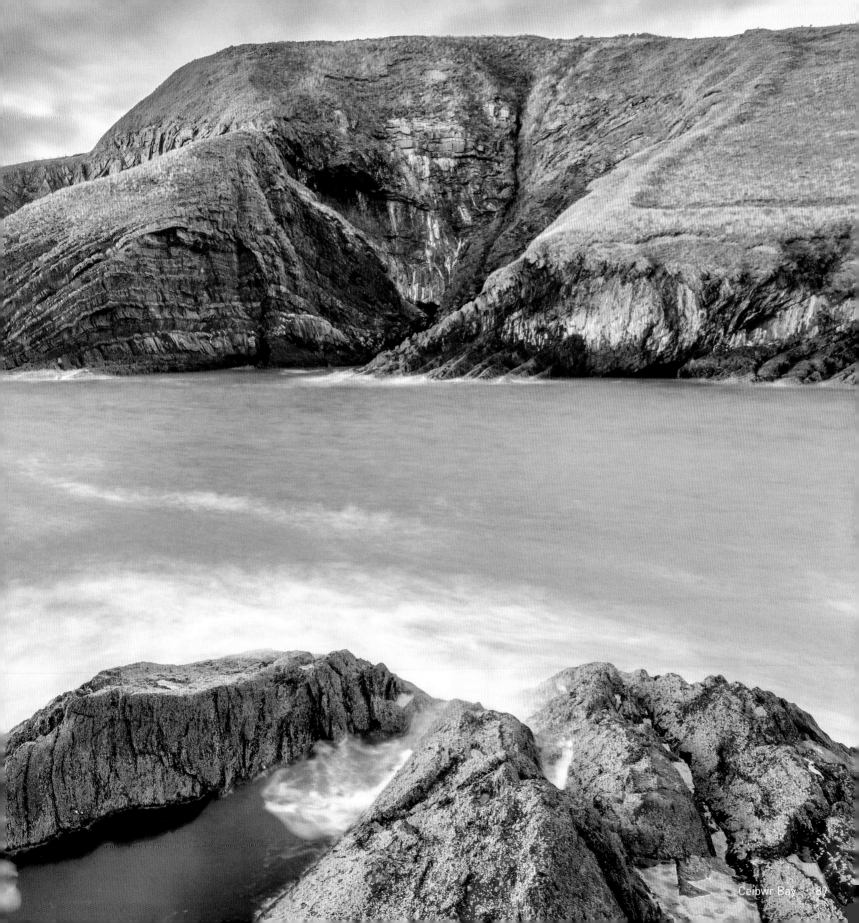

Ceibwr Bay 80

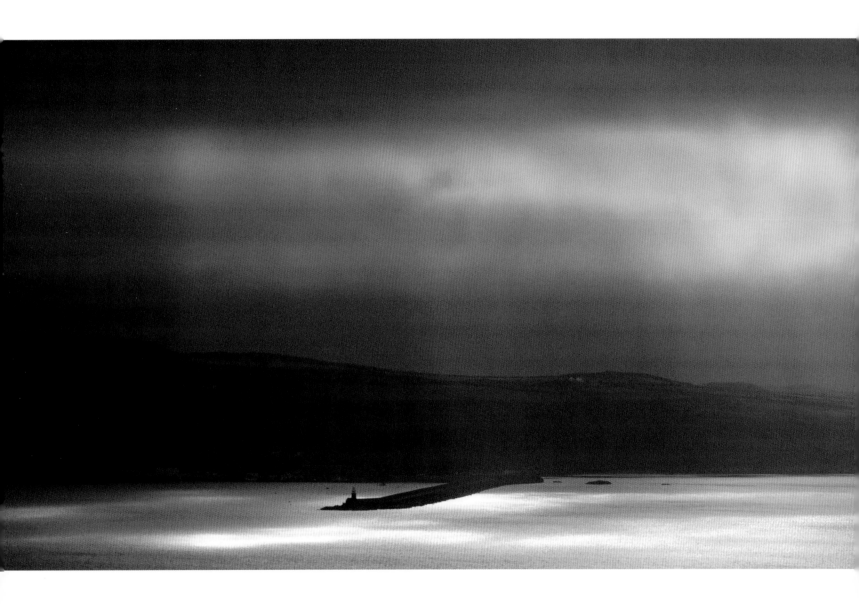

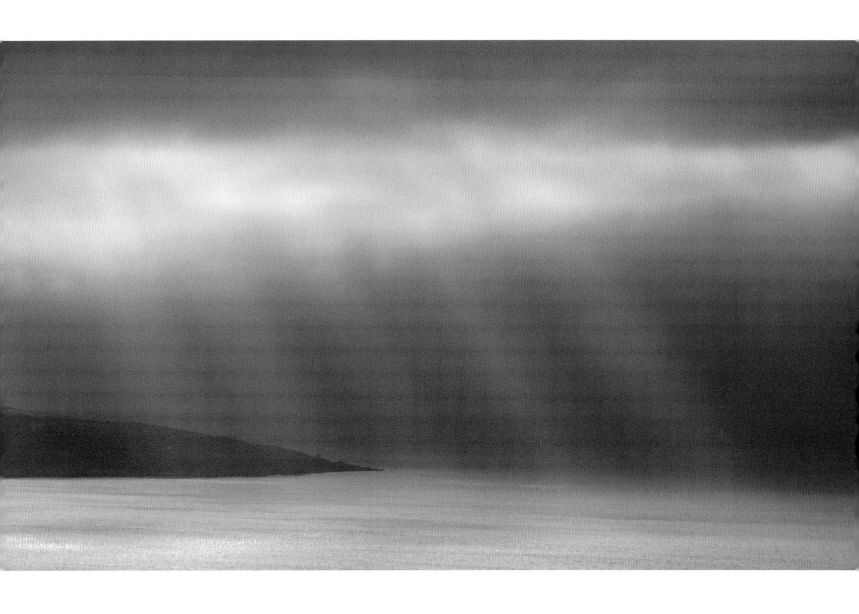

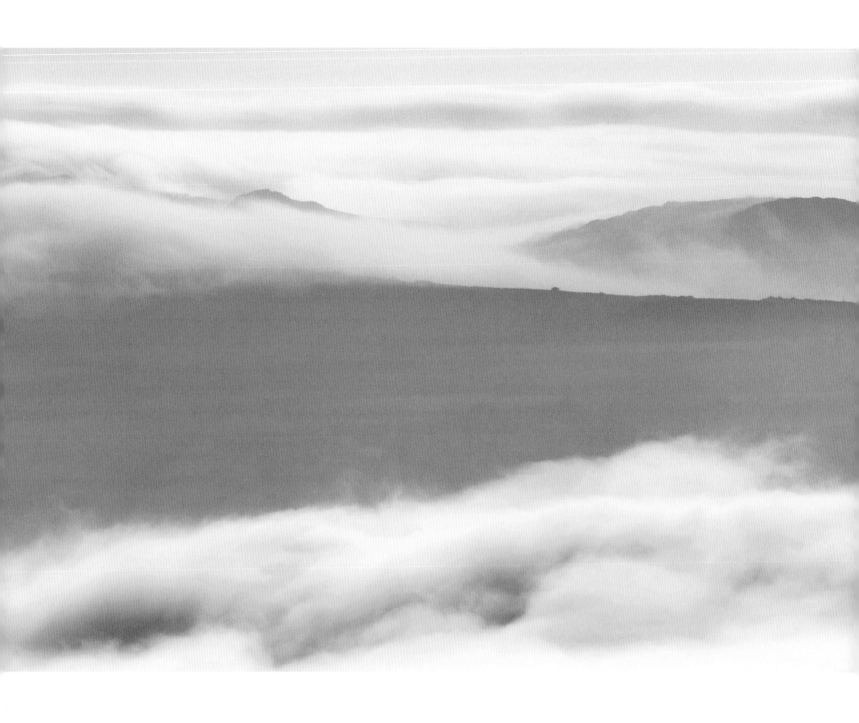

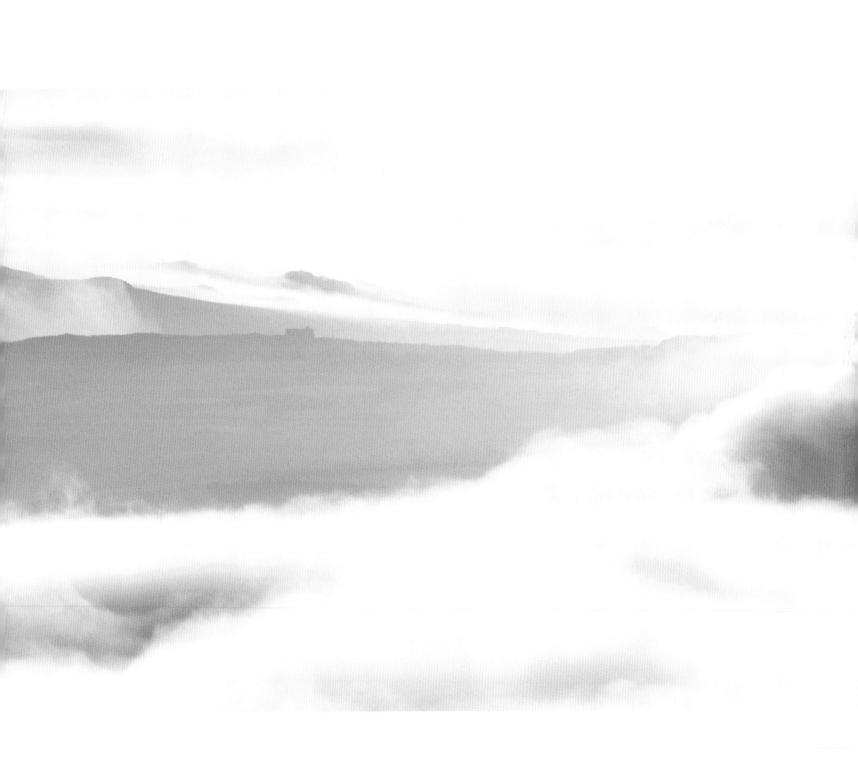

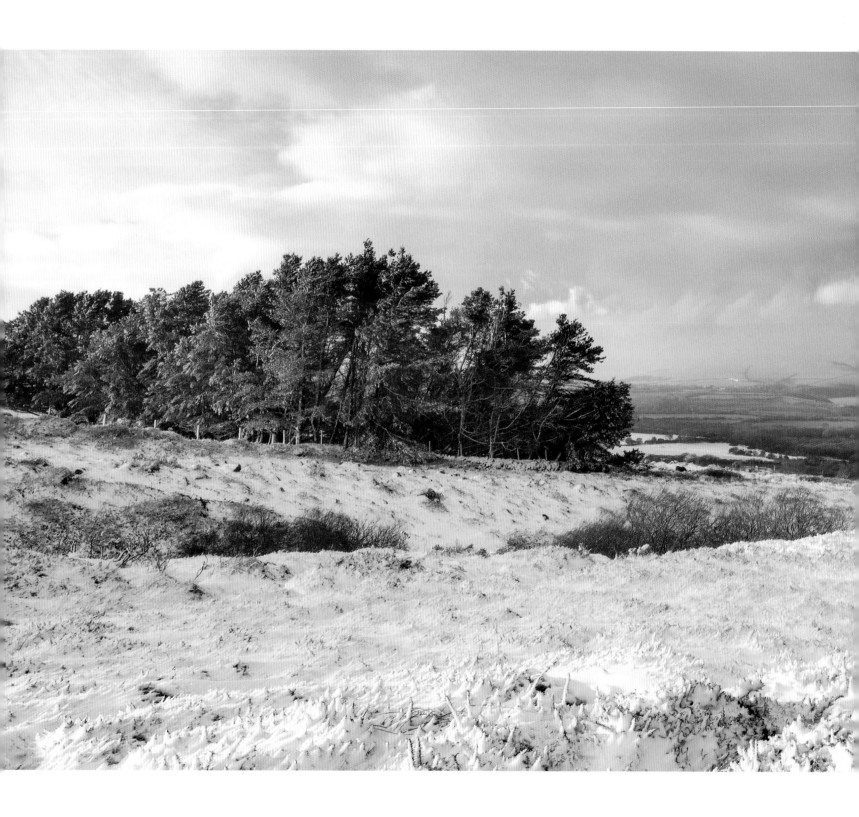

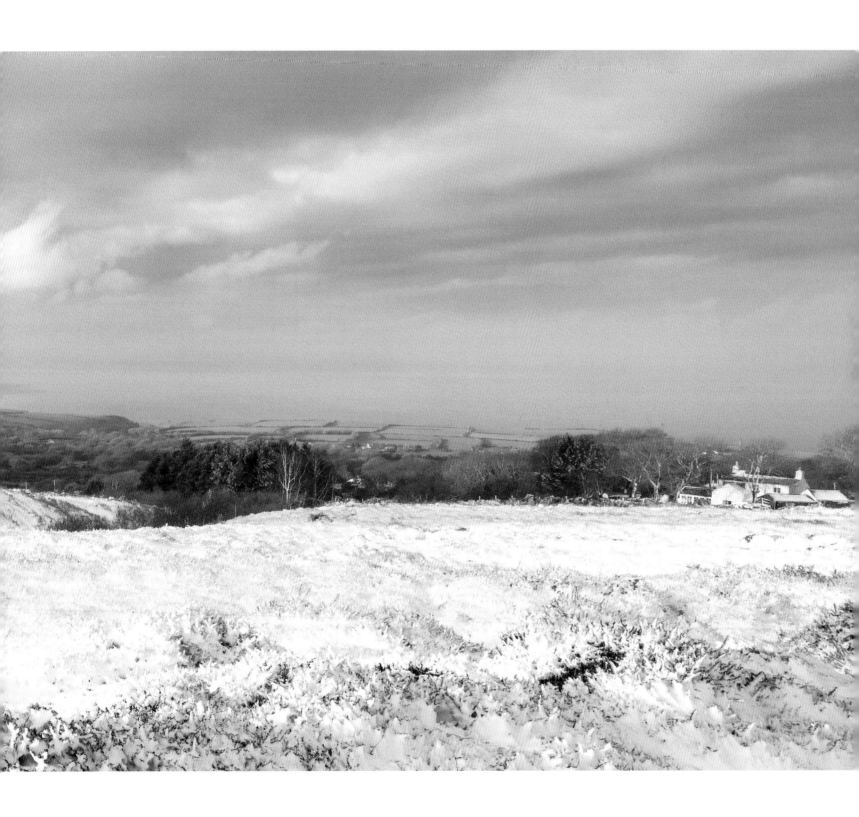

INLAND
PEMBROKESHIRE

WALES

43 Tycanol (Ty Canol)

42 Pentre Ifan

45 Overlooking Brynberian

50 Trinant Farm

44, 46, 47, 48 Preselis

49 Mynachlog-ddu

Pembrokeshire National Park

© Crown Copyright 2015 OS 100050715.

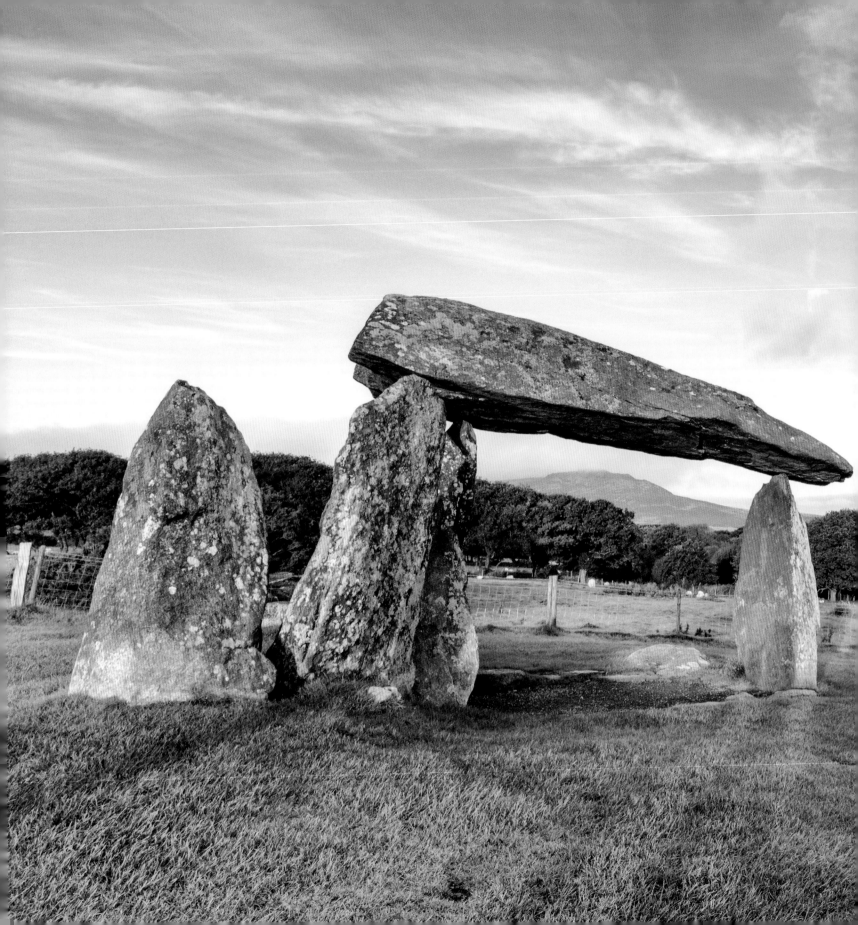

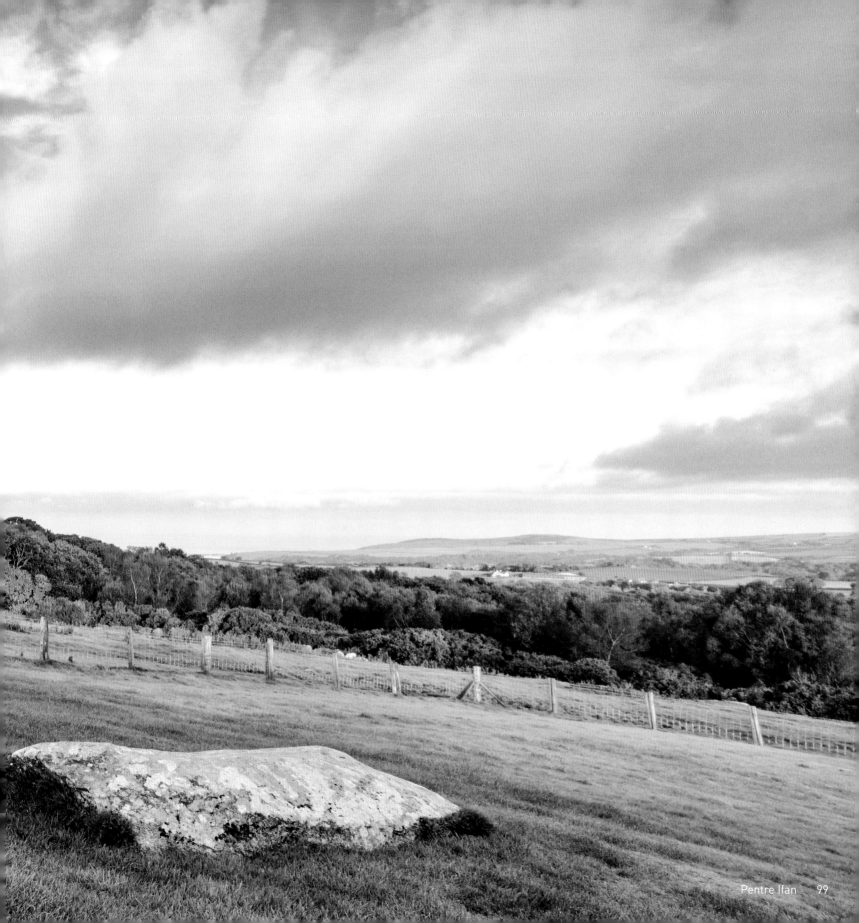

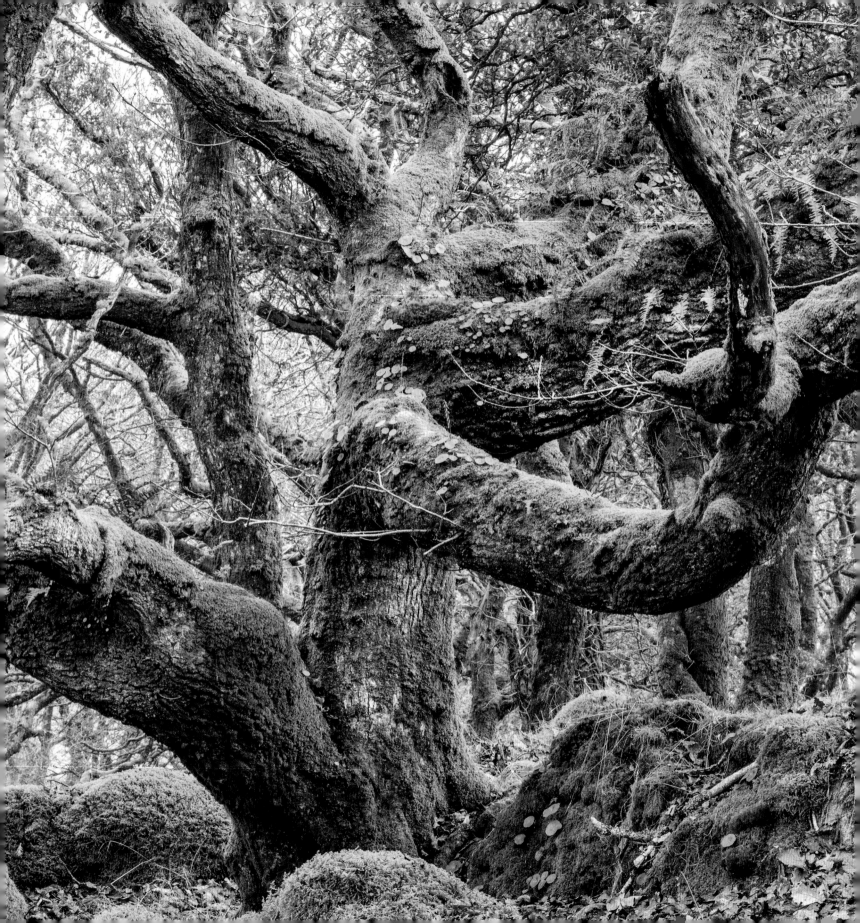

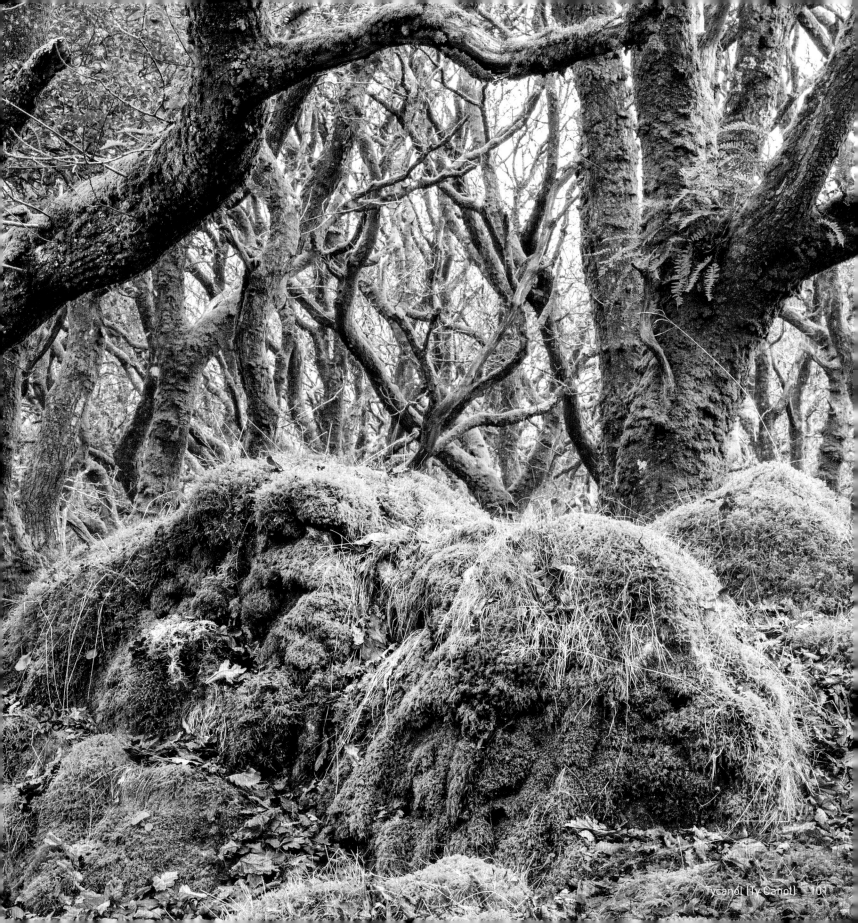

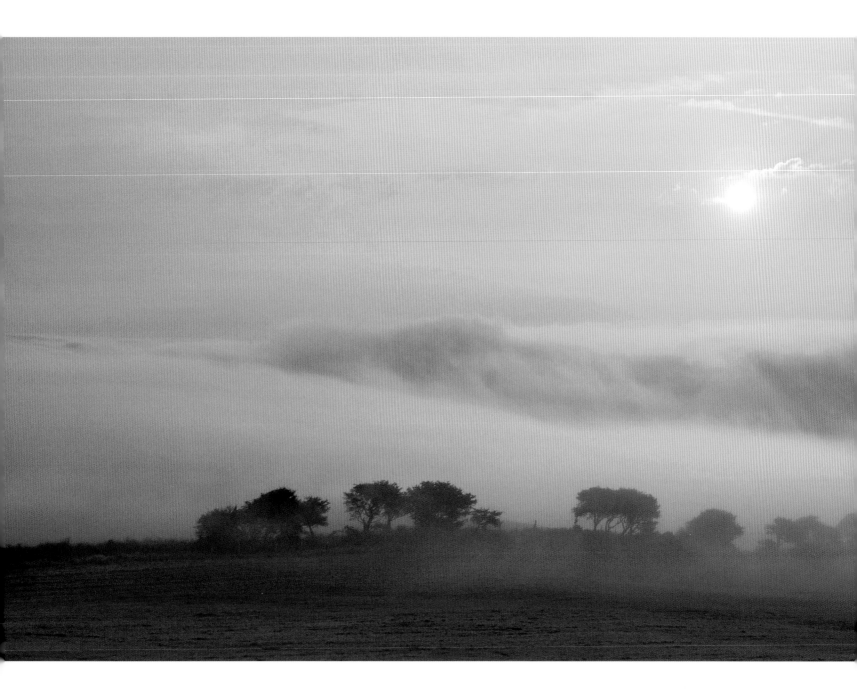

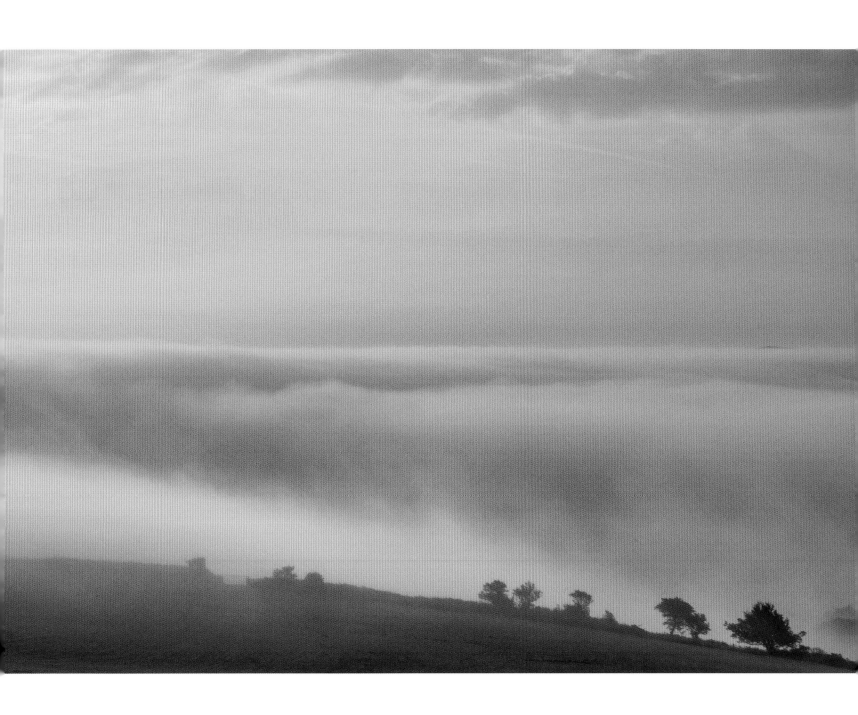

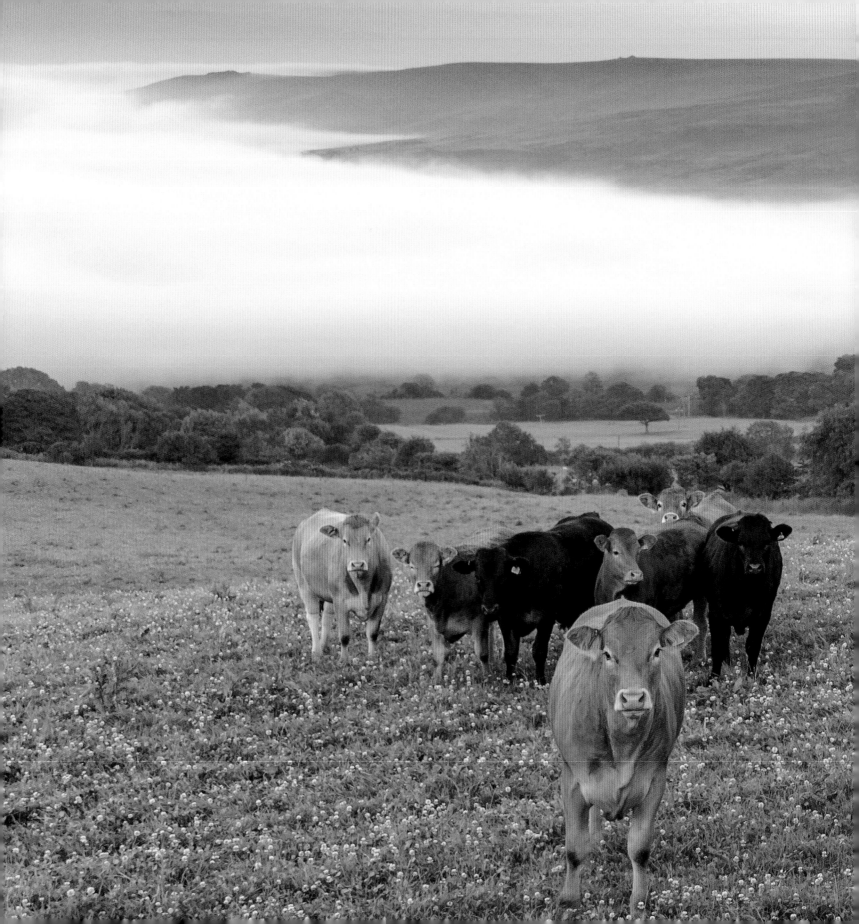

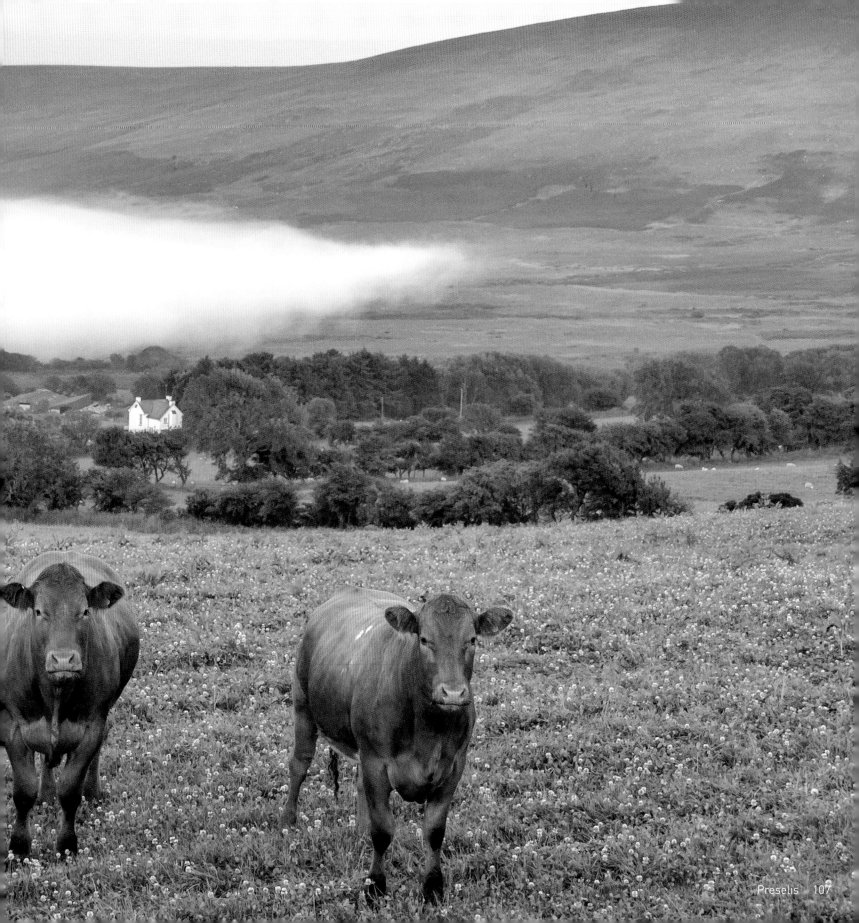

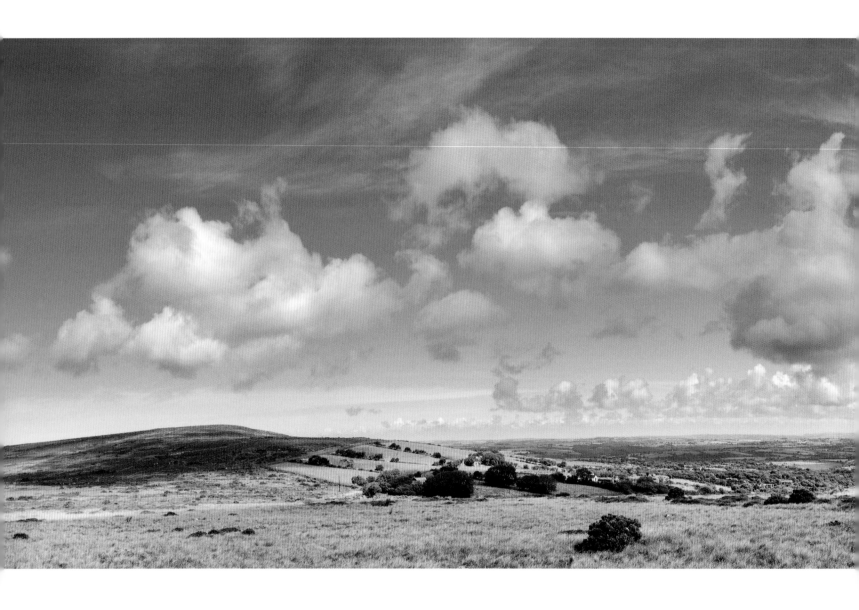

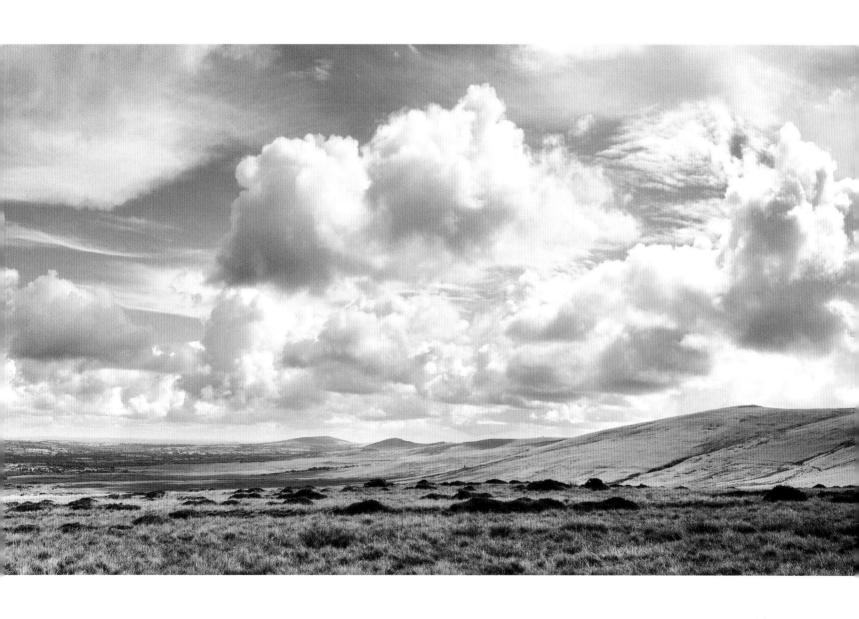

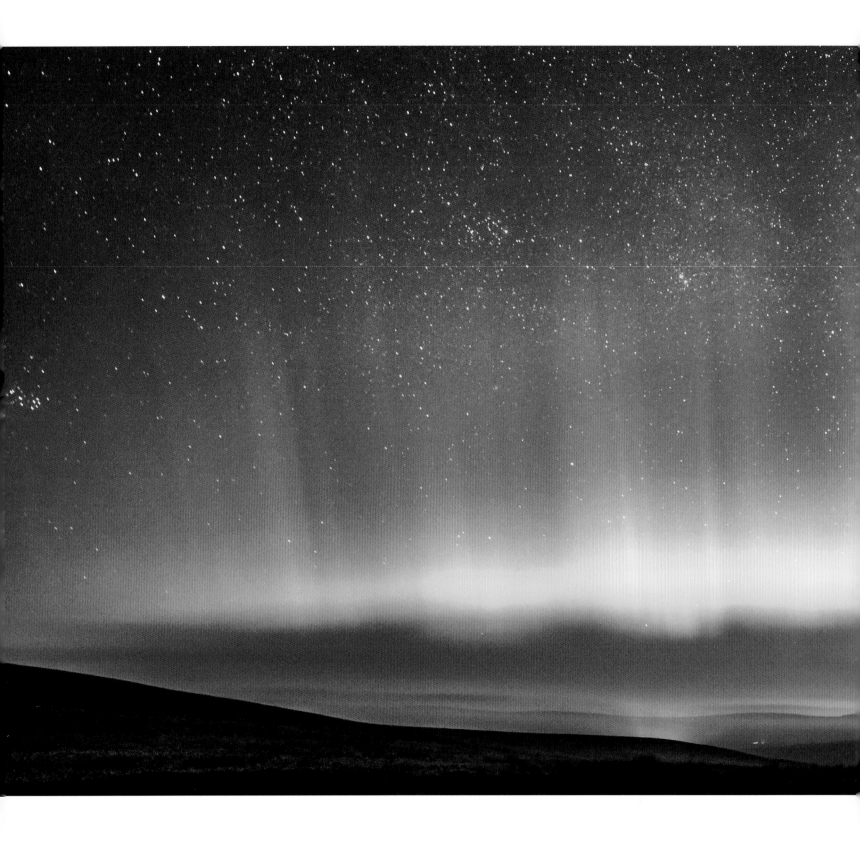

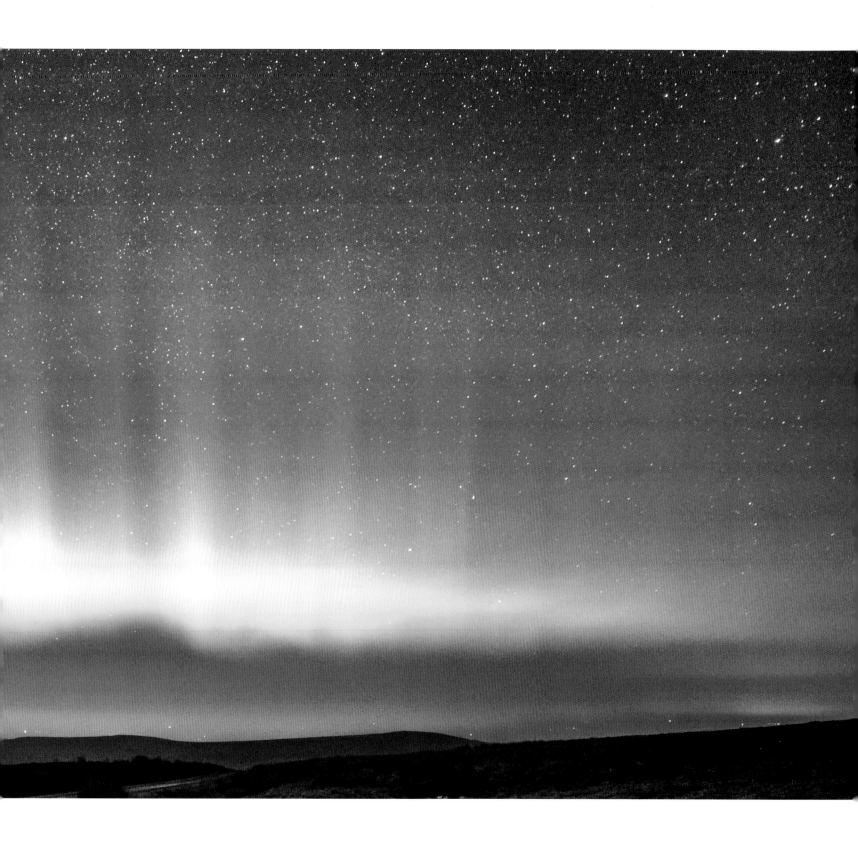

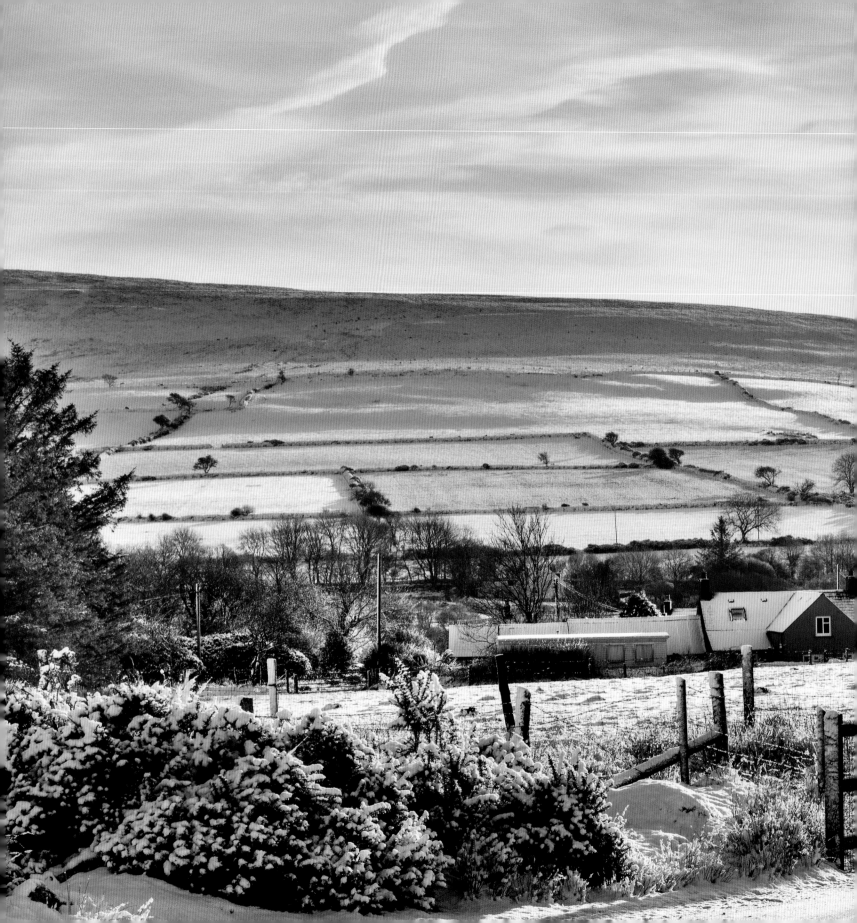

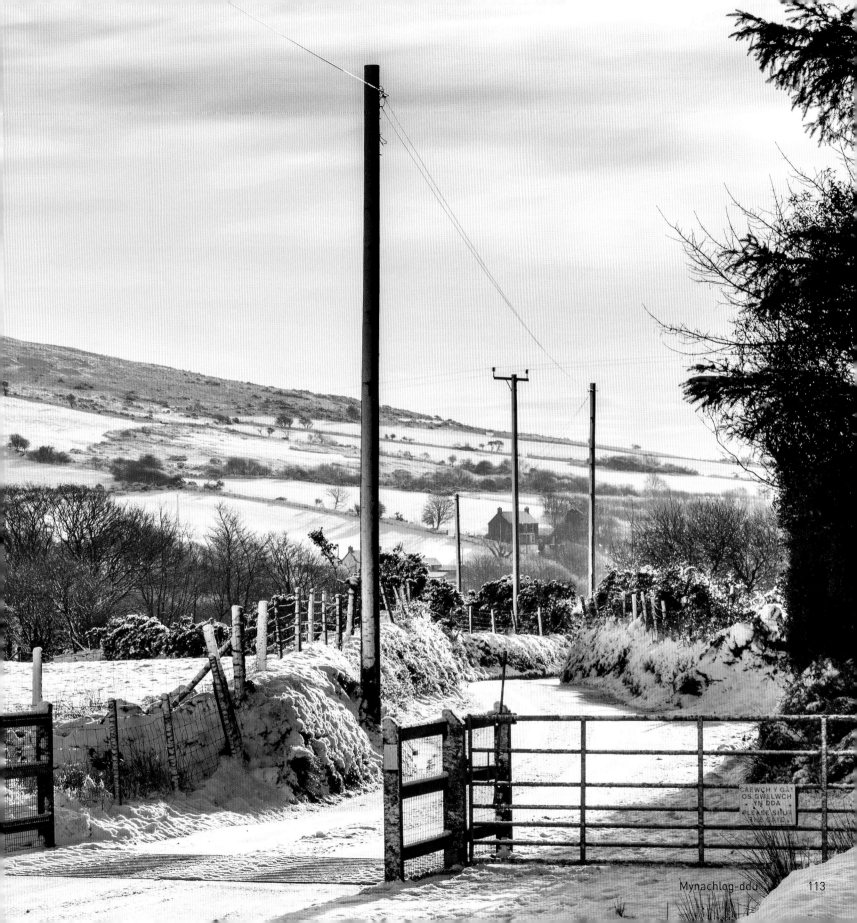

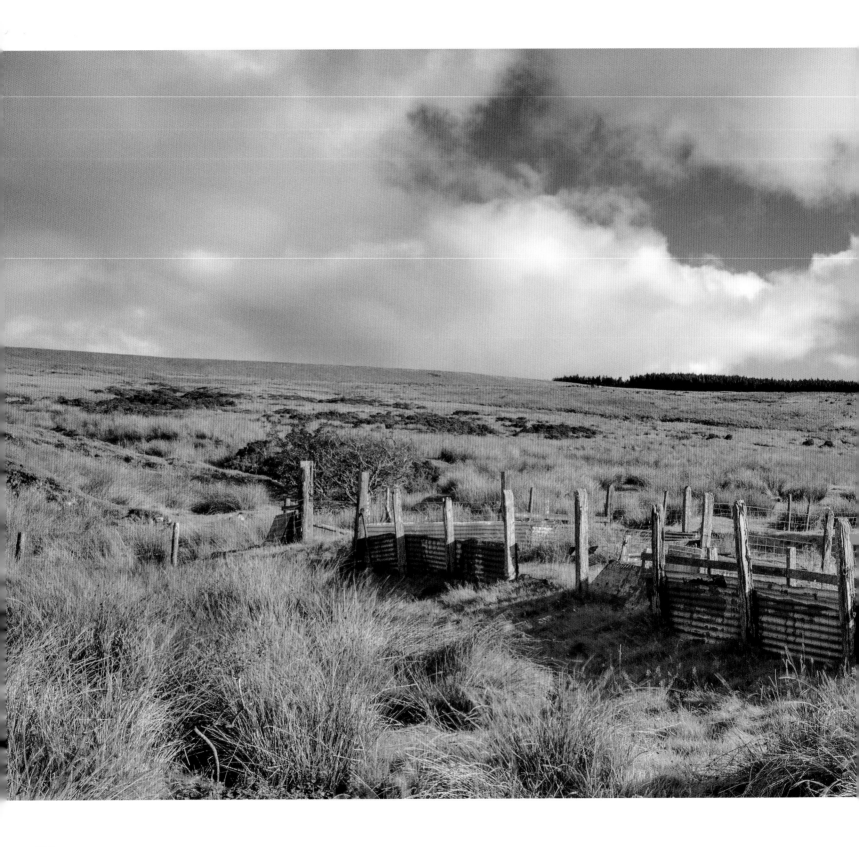

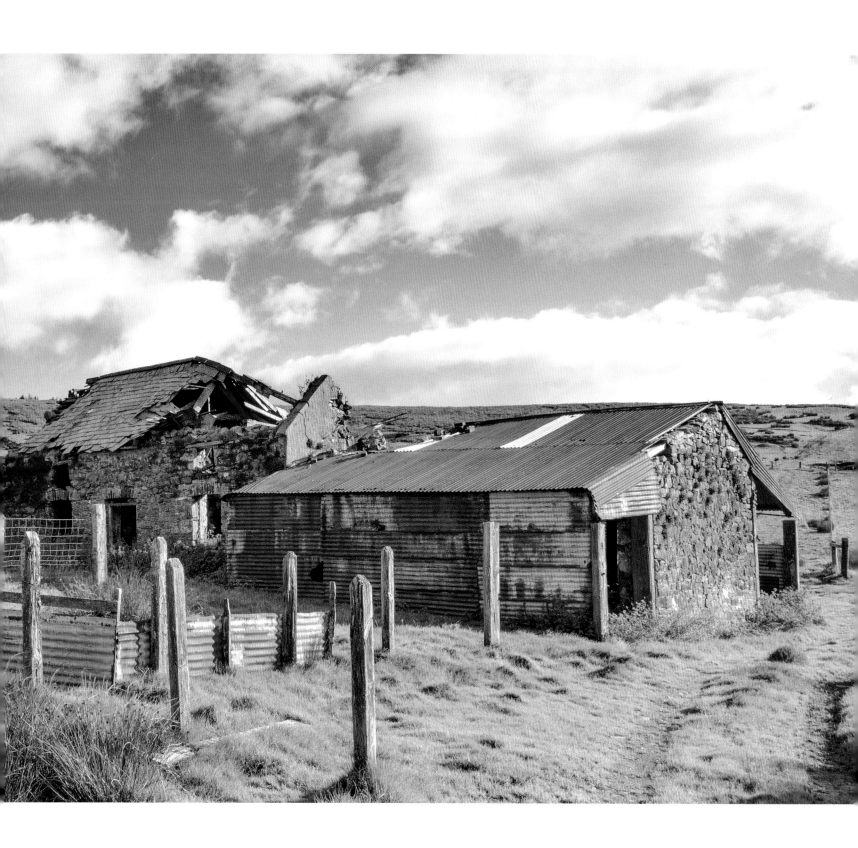

MAP OF PEMBROKESHIRE

WALES

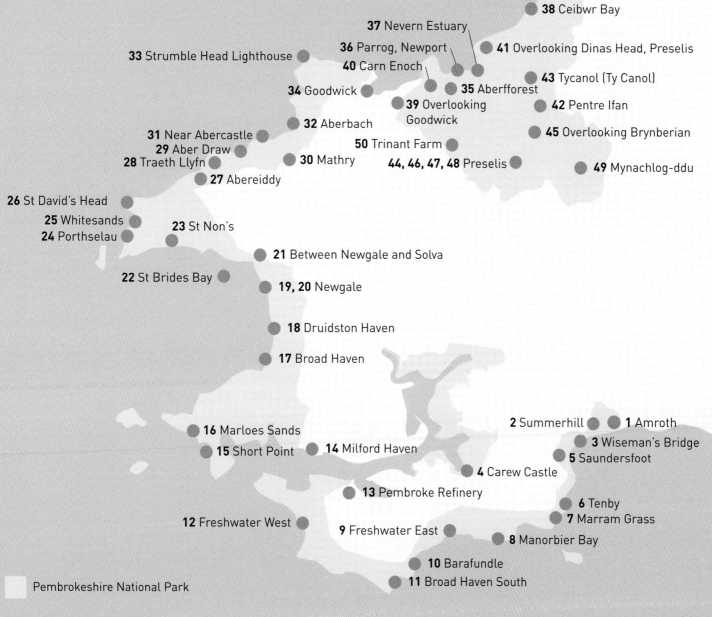

38 Ceibwr Bay

37 Nevern Estuary

36 Parrog, Newport

41 Overlooking Dinas Head, Preselis

33 Strumble Head Lighthouse

40 Carn Enoch

43 Tycanol (Ty Canol)

34 Goodwick

35 Aberfforest

42 Pentre Ifan

39 Overlooking Goodwick

32 Aberbach

45 Overlooking Brynberian

31 Near Abercastle

50 Trinant Farm

29 Aber Draw

30 Mathry

28 Traeth Llyfn

44, 46, 47, 48 Preselis

49 Mynachlog-ddu

27 Abereiddy

26 St David's Head

25 Whitesands

23 St Non's

24 Porthselau

21 Between Newgale and Solva

22 St Brides Bay

19, 20 Newgale

18 Druidston Haven

17 Broad Haven

2 Summerhill

1 Amroth

16 Marloes Sands

3 Wiseman's Bridge

15 Short Point

14 Milford Haven

5 Saundersfoot

4 Carew Castle

13 Pembroke Refinery

6 Tenby

12 Freshwater West

7 Marram Grass

9 Freshwater East

8 Manorbier Bay

10 Barafundle

11 Broad Haven South

Pembrokeshire National Park

© Crown Copyright 2015 OS 100050715.

INDEX

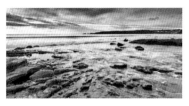
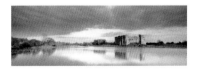
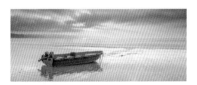

6. TENBY

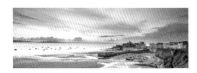

Tenby Harbour is probably one of the most recognisable harbours in Wales, if not the UK. Its name in welsh 'Dinbych-Y-Pysgod' means 'little town of the fishes' or 'little fortress of the fishes'. Tenby has had a varied life over the years, from an important trading port to a Georgian / Victorian health resort. To this day it remains a popular location with locals and visitors alike. It's always harder doing dawn shoots in the summer, due to the time of the rising sun. During early August the sunrise is getting later, at around 6am. However as the best light can sometimes be during the hour leading up to sunrise, be prepared to get there early and wait. Oh, and don't forget the flask. **Page 20.**

Camera: Nikon D3x
Focal length: 16mm
Aperture: f/11
Shutter speed: 1/2 sec
ISO: 50

7. MARRAM GRASS

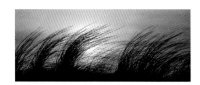

A familiar feature that can be found all around the coastline of Pembrokeshire, Wales and the rest of the UK. After a pleasant afternoon walk from Penally to Tenby's south beach I made my way up to Giltar Point, the headland at the far end of south beach overlooking Caldey Island.

Here I found myself surrounded by marram grasses that were gently swaying in the evening breeze. I positioned the grasses between myself and the setting sun and used a fast shutter speed to freeze the silhouetted grasses against the subtle palette of the dying sun. **Page 22.**

Camera: Nikon D3x
Focal length: 200mm
Aperture: f/7.1
Shutter speed: 1/8000 sec
ISO: 250

8. MANORBIER BAY

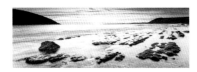

A popular sandy beach with bathers and surfers alike. On this afternoon I arrived at high tide and followed the tide back down the beach as it slowly went out, knowing that along its way it would reveal the long lines of rocks that had been submerged for the last couple of hours. **Page 24.**

Camera: Nikon D800
Focal length: 16mm
Aperture: f/14
Shutter speed: 3 sec
ISO: 100

9. FRESHWATER EAST

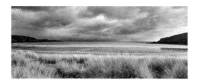

This is the beach closest to my home village of Lamphey, and it's where I spent many a hot summer's

day (yes Wales has them now and then) as a child. I probably covered every square metre of the beach and sand dunes system at some point when I was young. When I returned home with my camera for some reason I overlooked visiting Freshwater East for a while. When I finally did I had a certain shot in mind. Knowing that the winter's sun would be over the cliffs to the right, I arrived a couple of hours before sunset to make the most of the side lighting. I found a location in the dunes and waited. The rain clouds sweeping across the bay in the distance was a lovely bonus for me, but maybe not for anyone in the Tenby area at the time. **Page 26.**

Camera: Nikon D800
Focal length: 16mm
Aperture: f/14
Shutter speed: 1/25 sec
ISO: 100

10. BARAFUNDLE

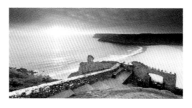

Pembrokeshire has many excellent beaches dotted along its coastline. One that has to be near the top of the list for most people is Barafundle Bay. Regularly getting a mention in 'best beach' awards, it sits on the Stackpole Estate which is now managed by the National Trust. This used to be the private beach of the Cawdor family, who once owned the estate. Parking at Stackpole Quay it's a good 15-20 minute walk to reach this wonderful location. On this January morning I positioned myself overlooking the empty beach using the familiar stone wall and archway as my lead in to the image. Knowing

that the sun would be rising directly in front of me, I placed my filters over my lens and waited for the sun to work its way over the horizon with just my thoughts and flask for company. **Page 28.**

Camera: Nikon D800
Focal length: 16mm
Aperture: f/14
Shutter speed: 1.3 sec
ISO: 100

11. BROAD HAVEN SOUTH

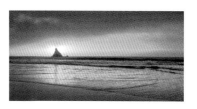

A wide sandy beach backed by sand dunes, just down the road from the village of Bosherston. As I drove to the location I wasn't filled with much hope. The clouds had come in fast and it seemed I had made a wasted journey. I parked the car and waited to see what the clouds would do. After a lengthy wait I was contemplating moving on when I noticed a thin break in the clouds moving towards the beach. Then all of a sudden the break got bigger, and sun broke through and the scene lit up. Church Rock proved to be the perfect focal point for the horizon, and also it was a great barrier to block the rising sun. In less than 15 minutes it was over. **Page 30.**

Camera: Nikon D800
Focal length: 35mm
Aperture: f/14
Shutter speed: 1/3 sec
ISO: 100

12. FRESHWATER WEST

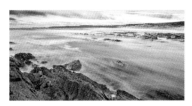

Freshwater West holds a special place in my heart. For one it's my grandmother's favourite beach and as child it is also the beach where we used to walk our dogs. Strong rip currents occur off this beach so it is never packed with bathers; instead it's popular with surfers, kite surfers, dog walkers, photographers and the odd film crew or two. It was here that parts of Robin Hood (starring Russell Crowe) and Harry Potter and the Deathly Hallows were filmed. I would have liked to stay in this location for a while longer, but the incoming tide had other ideas. I still managed to capture a handful of long exposures before retreating back to the beach. It's always good to keep an eye on your way back to safety when working around the sea.
Page 32.

Camera: Nikon D810
Focal length: 18mm
Aperture: f/14
Shutter speed: 15 sec
ISO: 64

13. PEMBROKE REFINERY

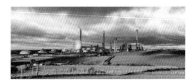

Originally came on stream in 1964, so it's been around longer than I have. Seen as an eyesore by some, I think its ugliness has its own unique beauty. I have driven past this refinery countless times and I am always sneaking a peak at how it is looking in the available light, day or night. Maybe it's just the photographer in me looking for an angle to capture it, or maybe as it has been here longer than I have, I just see it as part of the Pembrokeshire landscape. In the early 90's the village of Rhoscrowther was mainly purchased by Texaco, the then owners of the refinery. The properties acquired by them were then demolished. The last remaining houses, along with the church, can be seen at the base of the refinery.
Page 34.

Camera: Nikon D810
Focal length: 60mm
Aperture: f/11
Shutter speed: 1/60 sec
ISO: 64

WEST PEMBROKESHIRE

14. MILFORD HAVEN

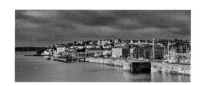

The town sits on the north side of the waterway from which it takes its name. The waterway has been used as a port since the Middle Ages, and is today one of the largest ports in the UK (in terms of tonnage). The town itself has been around since the 1790's. A friend of mine owns a flat overlooking the marina so a visit was planned for a calm morning. It's not often that I get handed coffee and biscuits on a balcony in the warm (ish) winter sun whilst my camera takes 30 second exposures. I'll take the little luxuries when I can in this game.
Page 38.

Camera: Nikon D810
Focal length: 56mm
Aperture: f/11
Shutter speed: 30 sec
ISO: 100

15. SHORT POINT

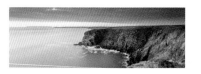

Situated on the Dale peninsula, between St Ann's Head and Westdale Bay. This was the first time I had explored this area and I noticed the cliffs had a red colour to them. I waited a short while until the sun started to set, knowing that if the clouds let the last light of the day through the red in the cliffs would be brought out even more. Thankfully it all fell into place that night. Off in the distance you can see the headland around Marloes, and just behind that is Skomer Island.
Page 40.

Camera: Nikon D3x
Focal length: 16mm
Aperture: f/16
Shutter speed: 4 sec
ISO: 50

16. MARLOES SANDS

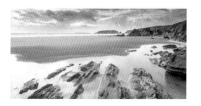

A long and remote beach near the village of Marloes. When the tide is out, there is a vast sandy beach dotted with rugged rocks to explore, but at high tide the area you can access is small in comparison. The walk from the car park to the beach is about 10-15 minutes, so I'd recommend checking the tide times before you go. In my opinion Marloes is one of Pembrokeshire's finest beaches, and is a wonderful

place to explore with your camera. Hollywood even came calling a few years back when they used the beach in the film *Snow White and the Huntsman.*
Page 42.

Camera: Nikon D800
Focal length: 16mm
Aperture: f/14
Shutter speed: 1/5 sec
ISO: 100

17. BROAD HAVEN

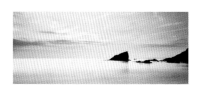

Just to confuse you we have 2 beaches in Pembrokeshire called Broad Haven. This one is also referred to as Broad Haven North, and is located on the west coast of Pembrokeshire, in St Brides Bay. Like its namesake it also known for a distinct triangular rock, this one being called Emmet Rock, which is accessible from the beach at low tide. The tide was slowly coming in on this evening, and the sea was like a mill pond, so I decided on a long exposure to smooth the sea out completely and add to the tranquillity of the moment.
Page 44.

Camera: Nikon D800E
Focal length: 28mm
Aperture: f/14
Shutter speed: 25 sec
ISO: 100

18. DRUIDSTON HAVEN

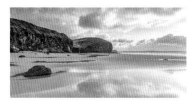

This is a beach I didn't discover until I came back home to Pembrokeshire, and I have made up for it with many visits over the years since I returned. It's not the easiest place to visit, as parking on the road is extremely limited. One way around that is to stay in the hotel, just out of sight at the top of the cliffs. Like a lot of beaches locally there is little access at high tide, but at low tide a big sandy beach is exposed, along with some lovely rock formations in the cliffs above.
Page 46.

Camera: Nikon D800
Focal length: 16mm
Aperture: f/11
Shutter speed: 1/2 sec
ISO: 100

19. NEWGALE

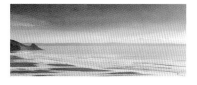

As Newgale is Pembrokeshire's longest beach I thought it warranted 2 entries in the book. At the one end is the distinct shape of Rickets Head. I wanted an image from above, so I walked up the headland behind Newgale. This evening was one of those when the sunset just kept giving, lasting for well over an hour. There were many people on

the beach that night, enjoying the beautiful evening, but one solitary person near the sea stood out for me and helped add a sense of scale to the image.
Page 48.

Camera: Nikon D810
Focal length: 70mm
Aperture: f/14
Shutter speed: 1/3 sec
ISO: 64

20. NEWGALE

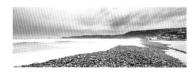

Roads run almost the full length of Newgale, just behind a large bank of pebbles that was left there after a big storm in 1859. Every now and then there is a storm that tests this natural sea defence, and one such storm happened in January 2014. The bank was pushed back by the sea on a number of occasions that month. This image was captured 2 days after the first collapse of the bank. I had to wait for the winds and the sea to calm down before I could stand on the pebbles with my tripod, but had to keep one eye on the sea at all times as it was still making its way over. The road was somewhere under the pebbles in front of me.
Page 50.

Camera: Nikon D800
Focal length: 16mm
Aperture: f/14
Shutter speed: 4 sec
ISO: 100

21. A487 BETWEEN NEWGALE AND SOLVA

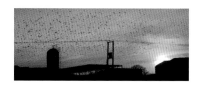

I was out looking for some Starlings to photograph, and not having much luck, as they all seemed to fly off in the direction where I couldn't follow. They then decided to settle on the wires over this farm, which happened to have a conveniently placed lay-by nearby. So there I stood with my camera at eye level, waiting for some movement. Nothing. The light was fading fast, but still they just sat there. For over 10 minutes I stood there with my camera at my eye, but they refused to move. Then, all of a sudden, there was the sound of a tractor starting up. The birds took to the air and my wait was over.
Page 52.

Camera: Nikon D3
Focal length: 82mm
Aperture: f/8
Shutter speed: 1/4000 sec
ISO: 320

22. ST BRIDES BAY

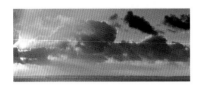

St Brides Bay is an area of water on the west coast of Pembrokeshire that stretches from Skomer Island to Ramsey Island. It's home to some of the best beaches, surfing locations and coastline in Pembrokeshire. It is also often used by the large ships, waiting to get into the Milford Haven waterway, as a parking spot or as shelter for them during rough seas. **Page 54.**

Camera: Nikon D3x
Focal length: 70mm
Aperture: f/11
Shutter speed: 1/6 sec
ISO: 100

23. ST NON'S

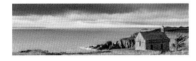

Just outside the city of St David's is this beautiful location. Along this stretch of coastline are the ruins of St Non's Chapel, held by tradition to be the birthplace of St David. A short walk brings you to the Chapel of Our Lady & St Non, which was built in 1934 using many stones from ruined pre-reformation chapels in the area. Getting a shot of this location was a labour of love. I must have visited the location about 8 times before all the elements fell into place. **Page 56.**

Camera: Nikon D800
Focal length: 24mm

Aperture: f/14
Shutter speed: 1/4 sec
ISO: 100

24. PORTHSELAU

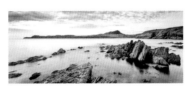

A small sandy sheltered beach at the south end of Whitesands Bay, near St David's. During a spring low tide it is accessible from Whitesands, but at all other times a walk of between 15-25 minutes is required to get there, unless you are staying at the nearby caravan/camp site or holiday cottages. I was asked to take some images of this location for somebody and liked it so much I have revisited it many times since. Be warned though, due to its proximity to the campsite, BBQs are cooked on this beach on a regular basis, and the smell is lovely but distracting. The headland in the distance is St David's Head, which is dominated by the peak of Carn Llidi. **Page 58.**

Camera: Nikon D800E
Focal length: 20mm
Aperture: f/14
Shutter speed: 25 sec
ISO: 160

25. WHITESANDS

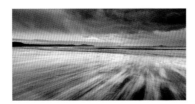

This wide sandy beach, popular all year round especially with surfers, is located just outside St

David's. This beach rarely fails to disappoint me when I visit, be it a spectacular sunset, raging seas, dark moody skies or the patterns of the retreating sea. I do love to set up my camera on the tripod on the water's edge and time my shutter release to when the sea pulls back. An exposure of around a couple of seconds can leave you with some lovely streaks of water on top of the dark wet sand. **Page 60.**

Camera: Nikon D800
Focal length: 16mm
Aperture: f/14
Shutter speed: 1.6 sec
ISO: 100

26. ST DAVID'S HEAD

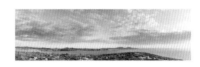

A dramatic headland, northwest of St David's, offering some spectacular views of this part of Pembrokeshire. Once up there you are spoilt for choice of which direction to go. Follow the coastline and many paths lead across the peninsula, or be brave and walk up Carn Llidi and get the best views. On this evening I didn't get too far, but the view was still great. The island in the distance is the RSPB reserve of Ramsey Island. **Page 62.**

Camera: Nikon D800
Focal length: 35mm
Aperture: f/14
Shutter speed: 1/13 sec
ISO: 100

NORTH PEMBROKESHIRE

27. ABEREIDDY

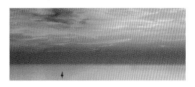

On a summer evening visit to Abereiddy I noticed this boat sailing around the headland from St David's Head. With the colours of the sky already starting to change I made the decision to make a quick dash up the coastal path to get a higher vantage point. I made it just in time to set up my camera before the boat sailed into my frame. Now I am not a lover of being on the sea, although I do love to photograph it, but seeing that boat slowly sailing past on the calm sea almost had me wishing I could have changed places with the people onboard. **Page 66.**

Camera: Nikon D800
Focal length: 70mm
Aperture: f/14
Shutter speed: 1/13 sec
ISO: 400

28. TRAETH LLYFN

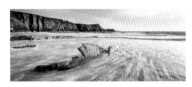

A secluded spot located roughly half way between Abereiddy and Porthgain and accessed by some steep metal stairs. It's a good 20-30 minute walk to reach this location, so on the times I have visited, I normally have had the beach to myself. To get the light on the rugged cliffs, it's best to visit in the summer. In this image, I am looking back towards Abereiddy, which was my route home once the sun had set. **Page 68.**

Camera: Nikon D800
Focal length: 16mm
Aperture: f/14
Shutter speed: 1 sec
ISO: 100

29. ABER DRAW

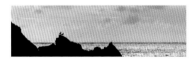

A small sheltered bay just outside the village of Trefin. Most people who live, or visit the coast, know that the gulls can be a nuisance to humans, wildlife and other birds, like the puffins. Occasionally though they will be well behaved and sit on a rock, with the sun setting behind them, and happily pose for you. Either that or they were planning on their next raid. **Page 70.**

Camera: Nikon D3x
Focal length: 200mm
Aperture: f/5
Shutter speed: 1/100 sec
ISO: 200

30. MATHRY

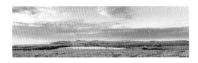

From its position sitting atop a hill, the village of Mathry offers some lovely vistas of the Pembrokeshire coast / countryside. I particularly love the view from the back of the village overlooking the beaches of Abermawr & Aberbach and onwards to Strumble Head. Even more so in late spring / summer when the landscape is full of colour and highlighted by the late evening sun. **Page 72.**

Camera: Nikon D800
Focal length: 48mm
Aperture: f/14
Shutter speed: 1/15 sec
ISO: 100

31. NEAR ABERCASTLE

During a summer evening drive, not far from Abercastle, I stumbled across this large field swaying gently in the evening breeze. I managed to find a pull in, which on the back lanes of Pembrokeshire isn't easy, and walked up and down the lane looking for a good view point. Thankfully at a gate there was this view. The dip in the land in the distance was needed to show the sea beyond to give greater depth in the image. All I had to do then was to wait for the gap in the clouds for the light to break. A ½ second exposure was just right to give the field some movement, whilst retaining detail. **Page 74.**

Camera: Nikon D800E
Focal length: 48mm
Aperture: f/14
Shutter speed: 1/2 sec
ISO: 100

32. ABERBACH

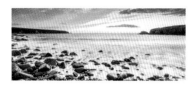

This has to be up there as one of my favourite locations in Pembrokeshire. A small beach which is made up of pebbles and rocks, it may not offer much for the bathers out there (Abermawr, its sister beach a few minutes' walk away is better for that), but for photography it's just perfect. Not a very crowded beach at the best of times, there has been many an evening I've been down there with just a few playful seals for company. The pebbles and rocks give you some foreground interest for your images, and if you want a bit of colour the sun sets around the entrance to the bay from about March to October. **Page 76.**

Camera: Nikon D800
Focal length: 16mm
Aperture: f/14
Shutter speed: 2 sec
ISO: 100

33. STRUMBLE HEAD LIGHTHOUSE

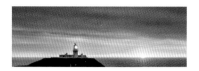

Located on the North West tip of Pembrokeshire, on the small islet of Ynys Meicel (St Michaels's Island), on the Pencaer peninsula just west of Fishguard. Built in 1908, this now fully automated lighthouse's light can be seen from 26 nautical miles away. You certainly feel cut off from the world when you are out there, even though it is well visited. This image was captured not far from the parking area, although if you don't mind a longer walk in late summer you can look back at the lighthouse with gorse and heather across the cliff tops. This area is also one of the best sites around locally where you can view porpoises. **Page 78.**

Camera: Nikon D800
Focal length: 38mm
Aperture: f/14
Shutter speed: 15 sec
ISO: 100

34. GOODWICK

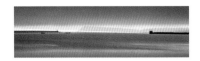

In 1797 the last invasion of mainland Britain happened just a few miles away, at Carregwastad Point on the Pencaer peninsula. The surrender of the French insurgents took place on Goodwick Sands. The harbour was also the setting for the Moby Dick film starring Gregory Peck. Nothing so exciting happened on this morning when I ventured down here though. I positioned the familiar shape of Dinas Head, which was fading in and out of view due to the fog, between the two breakwaters. The sun rising behind the bank of fog offered a thin strip of colour along the edges of the fog, reflecting on the sea in front of me. A long exposure did the rest. This was one of those days when Pembrokeshire was truly spilt. Whereas Newport (beyond Dinas Head) has a beautiful sunny cloudless day, the Goodwick side of Dinas spent the day under a thick blanket of fog. **Page 80.**

Camera: Nikon D800
Focal length: 58mm
Aperture: f/14
Shutter speed: 15 sec
ISO: 100

35. ABERFFOREST

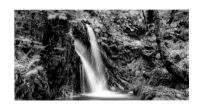

A small bay not far from Newport, on the north Pembrokeshire coast, with a hidden gem of a waterfall in the woodland behind. I only came across this location by word of mouth, as there were few photographs of it about, but now I guess the word is well and truly out. Looking up towards the waterfall you are facing south, so you really need to be here in the late afternoon or early evening on a spring / summer day to get the light falling in the right place. One thing Pembrokeshire lacks is an abundance of waterfalls, so this one was a joy to find. **Page 82.**

Camera: Nikon D800
Focal length: 22mm
Aperture: f/14
Shutter speed: 10 sec
ISO: 100

36. PARROG, NEWPORT

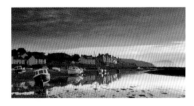

The Parrog has a long seafaring history from fishing, to import and export, to shipbuilding and on to the pleasure crafts, which make up most the boats in the old port today. To get this location void of people can require a lot of waiting and a stroke of luck. On this occasion I was all set up and ready to go, when just as the light got interesting, a group of children decided the water in front of me was the best location on the beach. I was about to pack up and move on when one of the dads kindly offered to take them on a wading adventure to Newport beach just across the water. I'm not sure the other parents were too happy when they had to carry most of the children across the water, as it was a little deeper than they thought. **Page 84.**

Camera: Nikon D800E
Focal length: 40mm
Aperture: f/14
Shutter speed: 1/13 sec
ISO: 100

37. NEVERN ESTUARY

Captured from the 'Iron Bridge' on the road between the town of Newport and the beach, over the tidal section of the River Nevern. It's a location that is popular with birdwatchers during the summer months. However, I had an idea in my head for this location for a while. All I needed was a misty morning at the right time of year. After a few failed attempts I awoke one September morning to mist, so I headed here knowing the location of the rising sun would be directly in front of me. I was hoping the sun would be able to burn through the mist just enough to give me this layers effect. Finally I had got my shot. **Page 86.**

Camera: Nikon D800
Focal length: 200mm
Aperture: f/14
Shutter speed: 1/30 sec
ISO: 100

38. CEIBWR BAY

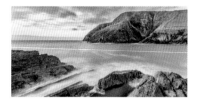

The beach is a tiny inlet of rocks and sand surrounded by some spectacular cliff formations. The cliff folds here are part of the Nant Ceibwr valley, which runs through the village of Moylegrove, and were originally formed by glacial erosion. **Page 88.**

Camera: Nikon D800
Focal length: 16mm
Aperture: f/14
Shutter speed: 10 sec
ISO: 100

39. OVERLOOKING GOODWICK, PRESELIS

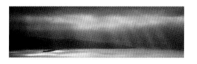

In the village of Dinas Cross there is a turning that leads you up into the Preselis. Just before you cross the cattle grids, there is a small car park giving you some lovely views of Dinas, Goodwick and Newport. It's a location I like to sit some evenings and watch the light dancing across the landscape. On this summer's evening, the dark clouds over Goodwick and beyond broke briefly and the rays of light danced across the harbour and the sea. **Page 90.**

Camera: Nikon D3
Focal length: 92mm
Aperture: f/14
Shutter speed: 1/100 sec
ISO: 200

40. VIEW FROM CARN ENOCH, PRESELIS

Just up from the previous viewpoint is Carn Enoch. I had spent most of the day in Newport surrounded by a thick swirling fog. It sometimes pays to go high, if you can, to see the extent of the fog coverage. I am so glad that I did. The fog turned out to be the thickest sea fog I had ever seen. Normally from here you can see out over Fishguard / Goodwick, Dinas, Newport and the sea off the north Pembrokeshire coast, but not on this day. This was the view towards Fishguard as the sea fog started to roll inland. Within half an hour I was trying to find my way back down to the car in thick fog.
Page 92.

Camera: Nikon D3
Focal length: 300mm
Aperture: f/8
Shutter speed: 1/2000 sec
ISO: 100

41. OVERLOOKING DINAS HEAD, PRESELIS

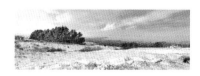

As a rule Pembrokeshire doesn't get much snow. Most years some of the lower areas will get a light dusting, and the Preselis might get to see a little more. This was captured during the winter of 2013. What I like about it is the contrast between the snow covered Preselis and the green strip of land between that and the sea. Normally there would be a few fields where the white of the snow fades to the green of the field, but that year there was a definite line between the two. The road getting there was the same, no snow then around the next corner covered in snow. Thankfully there was an area I was able to pull into before the slippery walk uphill began, occasionally diving out of the way of the 4x4's trying to make the hill in one go.
Page 94.

Camera: Nikon D800
Focal length: 16mm
Aperture: f/11
Shutter speed: 1/30 sec
ISO: 200

INLAND PEMBROKESHIRE

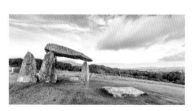

42. PENTRE IFAN

An impressive Neolithic Burial Chamber with stunning views over the Nevern Valley. The capstone alone, on this monument dating back to around 3500BC, weighs in at over 16 tonnes. I have photographed this location on most days of the week, and at many different times of those days, even at 2am with the Milky Way above it. Nothing prepared me for this morning though, as I composed my shot with Carningli (hill over Newport) positioned under the capstone and waited for the first light of the morning to illuminate the scene, I was joined by a local Druid. He wanted to perform a 'cleansing' of Pentre Ifan, but thankfully waited until I had got my shot before lighting his herbs and performing his cleanse.
Page 98.

Camera: Nikon D800
Focal length: 16mm
Aperture: f/14
Shutter speed: 1/6 sec
ISO: 100

43. TYCANOL (TY CANOL)

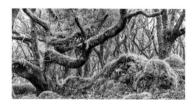

Near to Pentre Ifan is the ancient woodland of Tycanol, now a National Nature Reserve, which is representative of the type of forest that surrounded the burial chamber when it was built. The woodland, with trees over 800 years old, is one of the few remaining ancient woodlands in Wales and is known for the richness and variety of the mosses and lichen that grow on the rocks and trees under its canopy. With no official entrance it seems to be off most people's radar, and as a result every time I have visited I have been the only person around, which has given me many peaceful hours in the wood just wandering around looking for images in the chaos of the trees with only my thoughts, cameras and the birds for company.
Page 100.

Camera: Nikon D800E
Focal length: 70mm
Aperture: f/18
Shutter speed: 1 sec
ISO: 100

44. PRESELIS

I would like to say I walked for many miles to get to this location in time for the Preselis to start emerging from the early morning autumn mists, but in reality I know a great spot where you can park up and enjoy these views with your flask resting on the car. When I see a location I try to work out when it will work best, and in what conditions, and bank them for the future. This was one such place. I knew if I could catch it on a misty morning with the outline of the hills defined just enough, I could capture a simple yet powerful image.
Page 102.

Camera: Nikon D3x
Focal length: 185mm
Aperture: f/8
Shutter speed: 1/160 sec
ISO: 100

45. OVERLOOKING BRYNBERIAN, PRESELIS

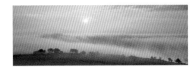

Captured not far from the previous image, but this time early one summer morning. This morning I had hoped for some misty shots of Pentre Ifan, but upon arriving I was greeted with about 5 parked cars and what sounded like a family party going on down there. Probably a good thing that they were there as it forced me to think of a plan B, which was get up high. I got to my second location and waited until the sun finally broke free and started to clear the sea of mist below. you could sit there for ages watching a landscape constantly changing as the mists swirl and transform the view before your eyes. In fact, I think that's what I did!
Page 104.

Camera: Nikon D800
Focal length: 32mm
Aperture: f/14
Shutter speed: 1/60 sec
ISO: 100

46. PRESELIS

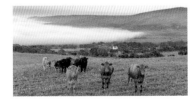

I had spent most of this evening higher up in the Preselis taking photos of swirling sea fog below, before it made its way inland and I had to retreat back to the car. On the drive home I broke free from the fog and found a spot to watch it slowly shroud the landscape in front of me. The plan was to use the cows happily munching away on the grass in the distance as some foreground interest, but as soon as the tripod and camera were in place I had an audience, which I think actually worked out better in the end.
Page 106.

Camera: Nikon D3
Focal length: 40mm
Aperture: f/6.3
Shutter speed: 1/80 sec
ISO: 400

47. PRESELIS

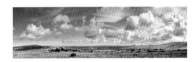

This is part of the view you are presented with when driving across the Preselis on the B4329, Haverfordwest to Cardigan road. Admittedly I had to park up and go for a little wander to get a car free view, but how could you just not love that view on a summer day?
Page 108.

Camera: Nikon D800
Focal length: 28mm
Aperture: f/14
Shutter speed: 1/200 sec
ISO: 160

48. PRESELIS

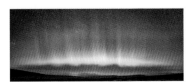

The Aurora Borealis, more commonly known as the Northern Lights, over the Preselis on St Patrick's day (17th March) in 2015. On this evening the Aurora was going to be visible over most parts of the UK, weather permitting, due to the biggest solar flare in around twenty years. Knowing this, and that we were due for a clear night, I headed up to the Preselis to get a high vantage point and some dark skies to see if I could catch a glimpse. I was not disappointed. Even this far south you could see the faint light of the Aurora by eye. The advantage with using a long exposure on a camera is that the camera picks up far more than the human eye can see. As a result I was able to capture some stunning Aurora Borealis light displays, before a thick bank of fog rolled in.
Page 110.

Camera: Nikon D750
Focal length: 14mm
Aperture: f/2.8
Shutter speed: 25 sec
ISO: 4000

49. MYNACHLOG-DDU

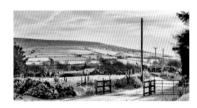

In the heart of the Preselis is the small village of Mynachlog-ddu. The morning sun was taking its time to break through the thin cloud covering on this morning, giving the sky a lovely warm glow for a good hour after sunrise. I was just driving out of the village and saw this in my rear view mirror. Worth stopping for I thought.
Page 112.

Camera: Nikon D810
Focal length: 70mm
Aperture: f/14
Shutter speed: 1/30 sec
ISO: 64

50. TRINANT FARM

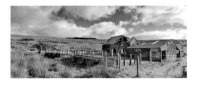

There are many old buildings dotted around Pembrokeshire, but there is something about this old farm ruin that I love more than most. I have been visiting this location, not far from the village of Rosebush, for many years now watching it slowly decay. Whenever I am wandering around here I can't help but think of how hard life must have been living and working here in this remote exposed location. At least they would have running water, albeit from a small stream in front on the house.
Page 114.

Camera: Nikon D800
Focal length: 22mm
Aperture: f/14
Shutter speed: 1/8 sec
ISO: 100

UNDER CELTIC SKIES
CALENDAR AND CARDS

Under Celtic Skies is a collection of stunning images which explore the open spaces and amazing colours that can be found around Wales throughout the year. The work of Pembrokeshire-born photographer Kersten Howard, these beautiful images celebrate the wide open spaces, the historic buildings and the stunning coastlines of Wales.

Enjoy Kersten's stunning images all year round with the Under Celtic Skies Calendar, or share these glorious snapshots of Wales with the Under Celtic Skies Notecards. Each notecard pack contains 10 notecards and envelopes. Notecards and Calendar from www.graffeg.com.

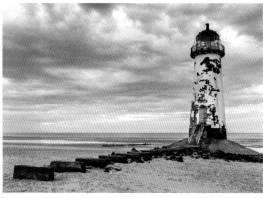

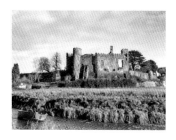

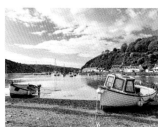

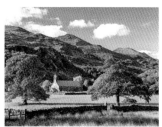

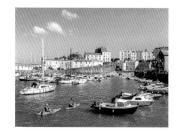

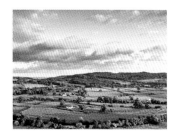

GRAFFEG
Calendars, notecards and prints available at www.graffeg.com

KERSTEN HOWARD PRINTS
FROM GRAFFEG

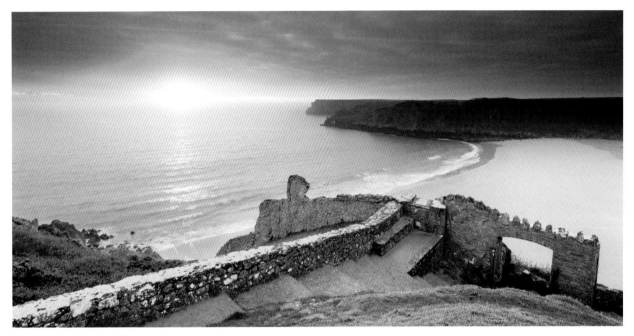

The Awakening, Barafundle, Pembrokeshire

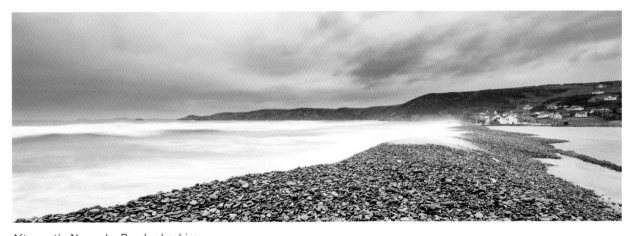

Aftermath, Newgale, Pembrokeshire

GRAFFEG

Order prints at www.graffeg.com